A COMMUNITY OF ANGELS

A COMMUNITY OF ANGELS

Los ANGELes

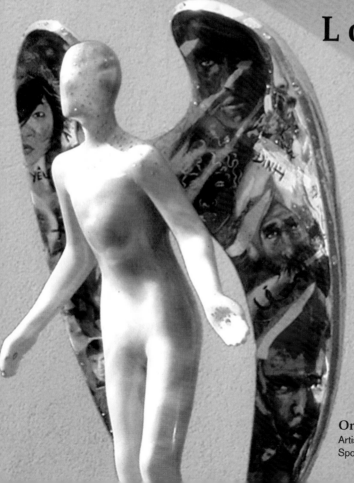

On the Wings of Angelenos
Artist: Alan Papaleo
Sponsor: LA Junior Chamber of Commerce

photographed by
Michele Dugan

written by
Marnie Tenden

designed by
Hannah Kaufman

ANGEL CITY PRESS

A COMMUNITY OF ANGELS
• Los ANGELes •

The Los Angeles public art project A Community of Angels[sm] was initiated by the Volunteers of America and the Catholic Big Brothers to raise funds to support vital programs for youth. Developed in association with the Los Angeles Convention & Visitors Bureau and the Volunteer Bureau of the Office of the Mayor, and sponsored by corporations, organizations, schools and individuals, the project showcases the work of hundreds of emerging and established artists.

Written by Marnie Tenden

Photographed by Michele Dugan

Designed by Hannah Kaufman

Copyright ©2001 by A Community of Angels

Visit A Community of Angels Web site at www.acommunityofangels.com

ISBN 1-883318-25-4

Angel City Press
2118 Wilshire Blvd. #880
Santa Monica, California 90403
310.395.9982
www.angelcitypress.com

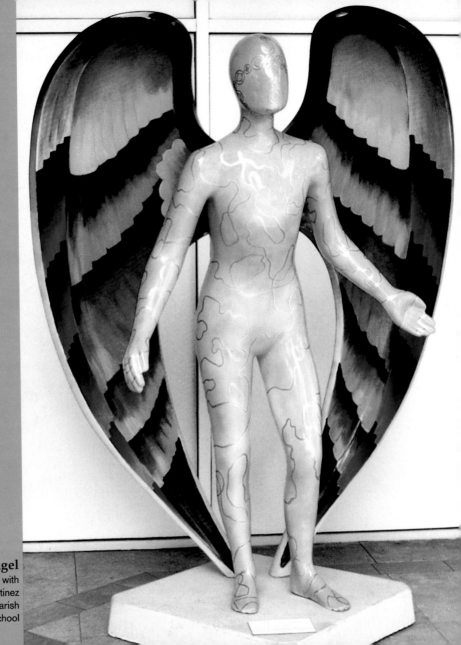

St. Monica's Angel
Artist: St. Monica Students with
Rita Luna Diamant and Dom Martinez
Sponsor: St. Monica's Parish
and High School

CONTENTS

Sunrise Sunset
Artist: Peggy Zask/Mira Costa High School Students
Sponsor: Mira Costa High School Community

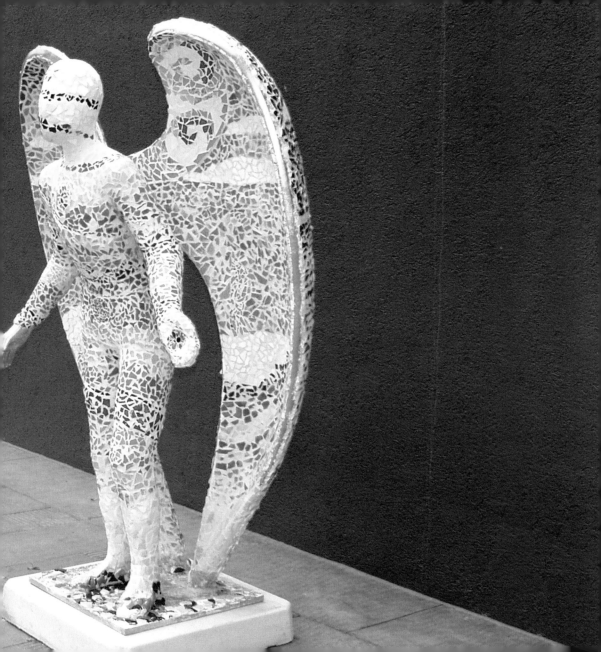

FOREWORD

For those of us who create art for a living, we have come to expect our completed products to effect others in unpredictable ways. What this project could not have prepared us for was the voracity and volume of the effect of our work on so many. The responses to the angel art works have reinforced our belief that, as artists, we can and do make a positive difference in our community.

The very nature of the project required of us a certain reverence and relevance we don't often attach to public art projects. Like putting on our finest Sunday outfit, work of this scope meant we had to bring our very best selves to this effort. Anything less, and you didn't admit it. . . *your angel would.*

The vision for my angel started even before I heard about the Community of Angels project. During a dinner conversation months ago at the home of my dear friend, Dr. Maya Angelou, the guests discussed how to market *good* in a climate where evil seems to be in the ascendancy, and aimed particularly at the hearts and minds of children. Later I would incorporate words as I transformed my angel into a colorful messenger on a mission to promote *good.*

When I had just completed my angel, and it was sitting in front of my studio, two young boys stopped, looked, and then excitedly told me my angel was "totally cool." But, they walked away whispering, "I just hope people don't graffiti all over it." Positive results from this Community of Angels project could help counter their all-too-familiar language of dread.

All of us, in our own way can find a way to promote good. Be it a painting, a word, a deed, a thank you or a smile, with some effort the Community of Angels will be more than a temporary project.

– Phoebe Beasley

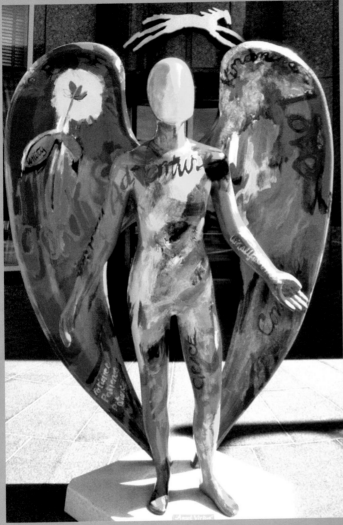

Angel Virtue
Artist: Phoebe Beasley
Sponsor: Northern Trust

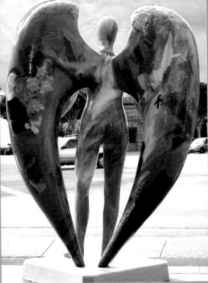

goodness
praise
unity
tenacity
love
discovery
grace
beauty
compassion
friendship
peace
understanding
unselfishness
humility
encouragement
hope
courage...
and patience,
patience,
patience.

INTRODUCTION

A Community of Angels. What you are about to see is heavenly. It celebrates the beauty of a city, it honors its past and it warmly embraces and reflects the cultural diversity that makes this city unique in all the world. It is at once the work of artists and the work of Los Angeles. Indeed, a Community of Angels.

When Father Juan Crespi bestowed the name Nuestra Señora de Los Angeles de la Porciúncula on this barren desert land crossed by a river, in 1769, it was a prescient moment. Angels do gather here. Living angels, and as we see in the pages of this book, angels of art, angels that speak more than their creators ever dreamed. The artfully embellished seraphim that have been blessing Los Angeles for the first several months of the new millennium are the result of a public art initiative benefitting children. It materialized because of the community of visionaries, volunteers, artists, businesses and community organizations who have made Los Angeles their home.

It was the spirit of community—of giving, sharing, loving, caring—that inspired Cal Winslow, vice president of the Volunteers of America in Los Angeles, to spearhead this exhibition of hundreds of beautiful angels for this City of Angels more than 230 years after Father Crespi named it. Eager to establish an icon for the city that could be interpreted by artists all over town—in the same way that Chicago and New York had their cows and Cincinnati had its pigs, Winslow declared, "This is the City of Angels. We must have angels."

So it came to be that a belief-neutral, androgynous, big-winged sculpted angel was created as the canvas for emerging and established artists to share their expressions of life and the spirit of Los Angeles. Artists in the community, emanating from every corner of the world, eagerly presented their concepts. Corporations, organizations, schools and individuals, each energetically and philosophically connected with the significance and purpose of this event, generously sponsored the creation of the artistically rendered angels you see pictured on these pages.

And what you'll read are the words from the artists who created the angels and experienced the wonder of having them in their lives. Many claim that mini-miracles happened when they opened their minds and hearts to their angels.

We can only hope that you share the wonder and the miracles of A Community of Angels—Los ANGELes, 2001.

— Marnie Tenden

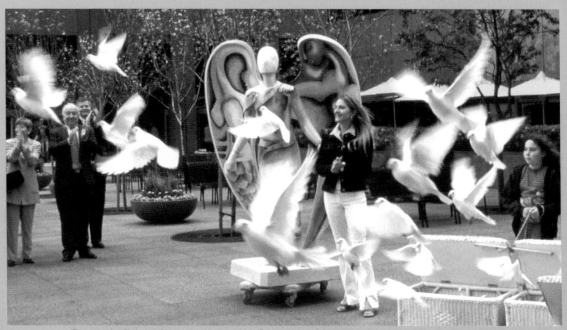

Doves take flight as Alexandra Nechita, the Community of Angels spokesperson, unveils Eyes of Light to the public.

THE ANGELS

Can you bring back the early times in life,
when you were the best at anything you put your mind to,
the mightiest,
the days of secret closest pals, or imaginary fairies?
It could be that these buddies
with whom we shared our highest convictions
and dark fears
and secret passwords
or deepest prayers were Angels.
Angels are carriers of immaculate love, compassion, and joy,
capable of doing seemingly impossible miracles.
Angels bring inner harmony,
help fight the most vicious thoughts and fears,
they help us conquer not only love
but a peace that is out of this world.
To some, Angels are non-existent, or distant,
perhaps they can only believe what their eyes can perceive—
maybe they have been looking in the wrong places—
The Angels were in front of their very eyes at all times.
Blinded by material things
and lost in the technology era and frenzy,
they are too lazy to see, too intelligent to accept,
yet, in desperate times too unprepared to endure alone.
It could be that the Angels are about ready to help bring forth the part of you
that never stopped believing in them.
I share my Angels with you,
hoping that you can feel their presence in your life
in some way.

– Alexandra Nechita
"The Messengers"

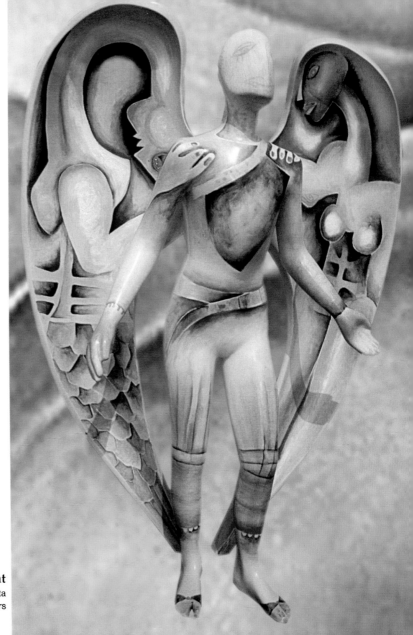

Eyes of Light
Artist: Alexandra Nechita
Sponsor: Maguire Partners

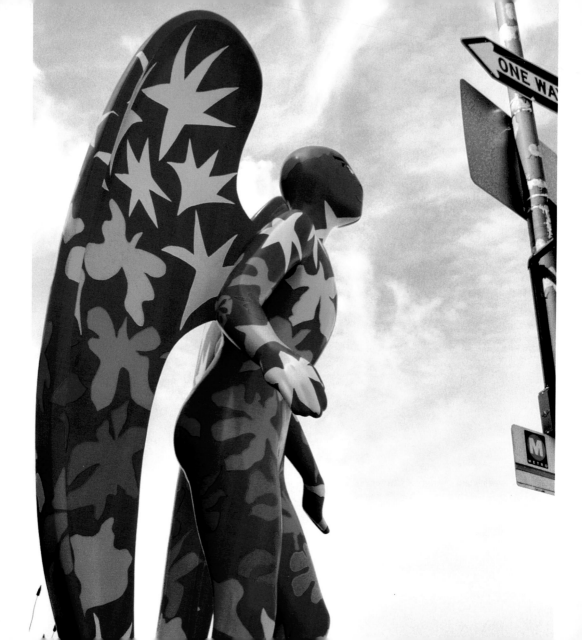

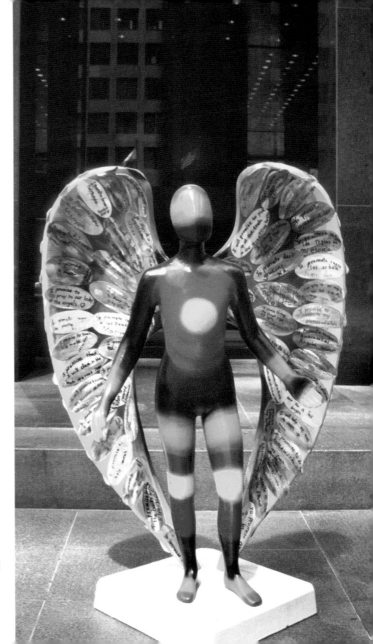

Children's Promise Angel
Artist: Paulina Granados and Children of Los Angeles
Sponsor: Bank of America

Everchanging Visions "Los Angelos" ◄
Artist: Dolores P. G. Kroop
Sponsor: Coldwell Banker Real Estate,
Podley, Caughey & Doan Old Pasadena Office

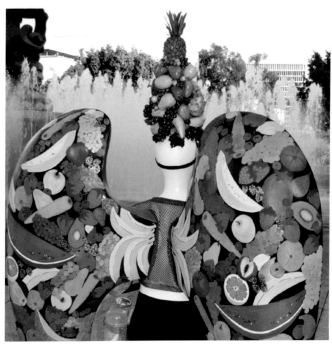

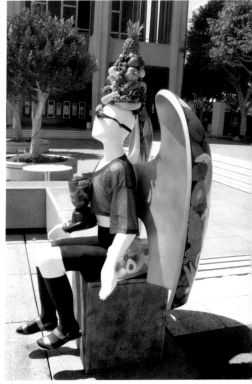

We wanted to create a sculptural satire of California living and LA personalities. We wanted Smoothie to express the unique character of the California lifestyle. He has come to earth and been transformed into an LA Smoothie.

— Elaine Wilson and Bruce Their

Smoothie
Artist: Elaine Wilson and Bruce Thier
Sponsor: Orange County Investments, Inc.

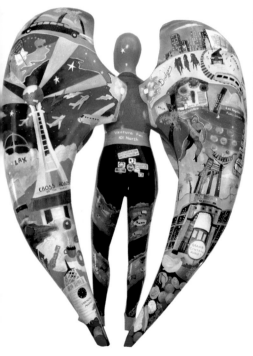

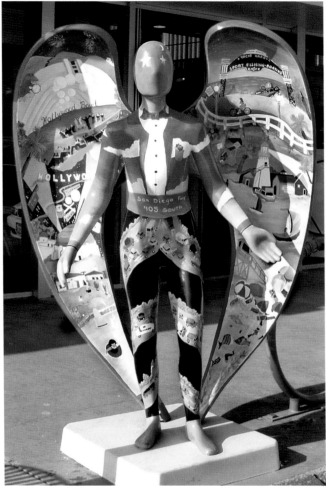

Puttin' On the Ritz
Artist: Linnea Pergola
Sponsor: Bel Air Camera & Video

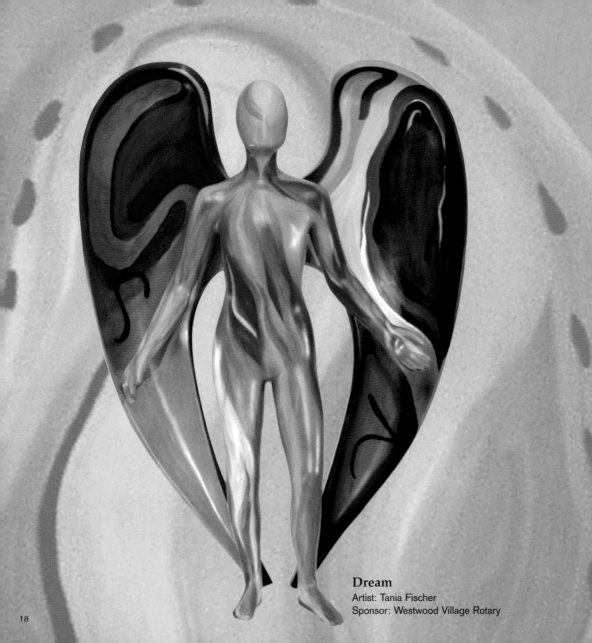

Dream
Artist: Tania Fischer
Sponsor: Westwood Village Rotary

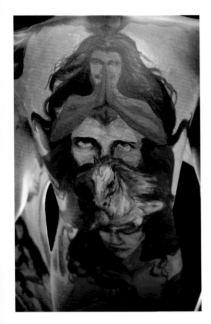

This angel represents the faces and energy of exaltation. From the exuberant to the sublime, the figures swirl and flow as personified energy en route to their connection with the infinite. The spectrum of colors represent those generated by the body's energy centers, the figures reflect the specific qualities associated with each center or with the flow of energy in the body.

— Dave Zaboski

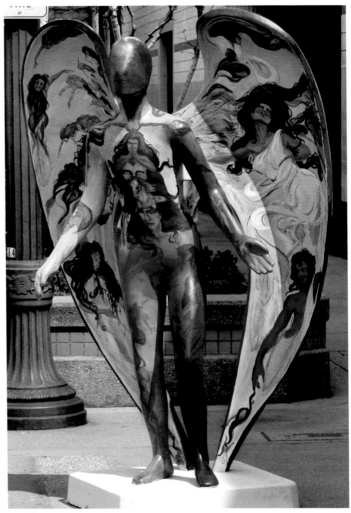

Exaltation
Artist: Dave Zaboski
Sponsor: Alhambra Central Business District Association

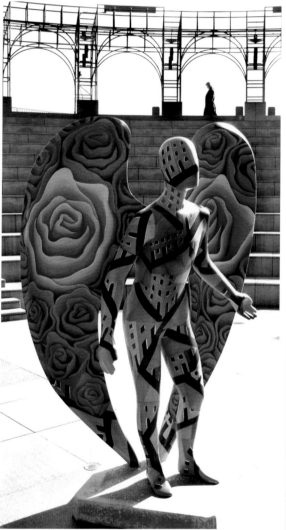

My son and I decided to combine our styles and juxtapose the manmade with the natural elements of Los Angeles. I painted the body and Gus painted the wings.

— Fielden Harper

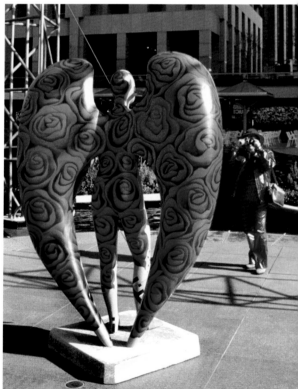

Angel of the City
Artist: Fielden and Gus Harper
Sponsor: Wallis Foundation

The angel is the Central City Association's gift to the City of Los Angeles. The CCA, through its advocacy, is devoted to promoting the health and vitality of LA as an economic engine and particularly its downtown.

— Janine Anderson

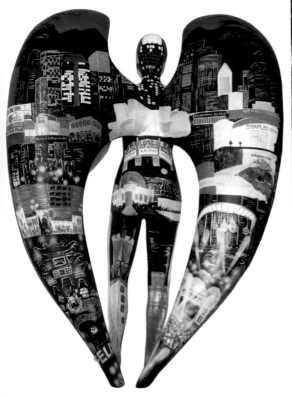

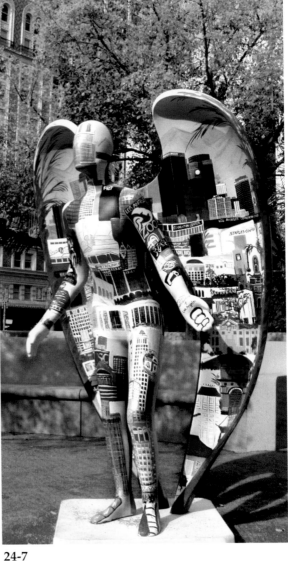

24-7
Artist: Janine Anderson
Sponsor: Central City Association

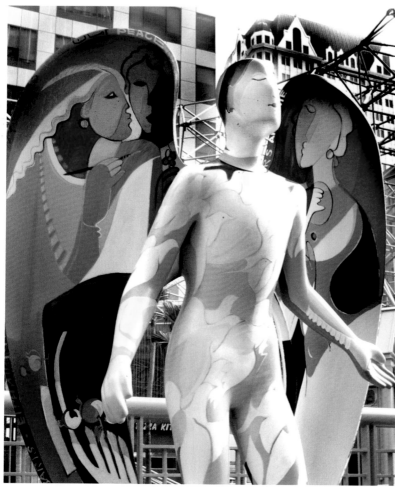

I wanted to say "peace" in several languages to represent the diversity of Los Angeles. If there be peace in LA, my hope is that peace may exist around the world.

— Ali Golkar

Peace
Artist: Ali Golkar
Sponsor: Marian Mann and Reeve Chudd

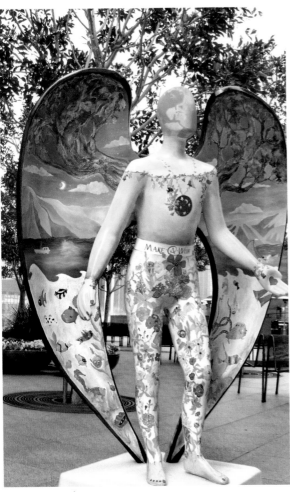

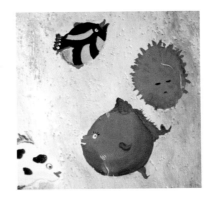

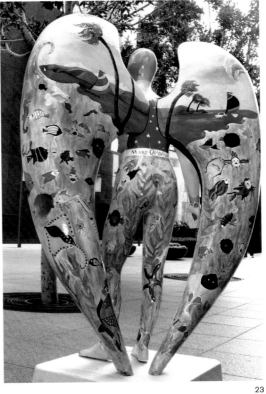

Earth Angel
Artist: Linnea Pergola
Sponsor: The Peterson Foundation for the
Los Angeles Make-A-Wish Foundation

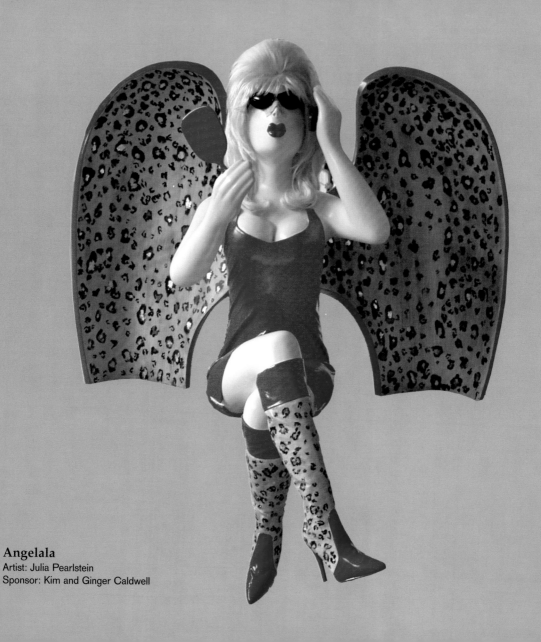

Angelala
Artist: Julia Pearlstein
Sponsor: Kim and Ginger Caldwell

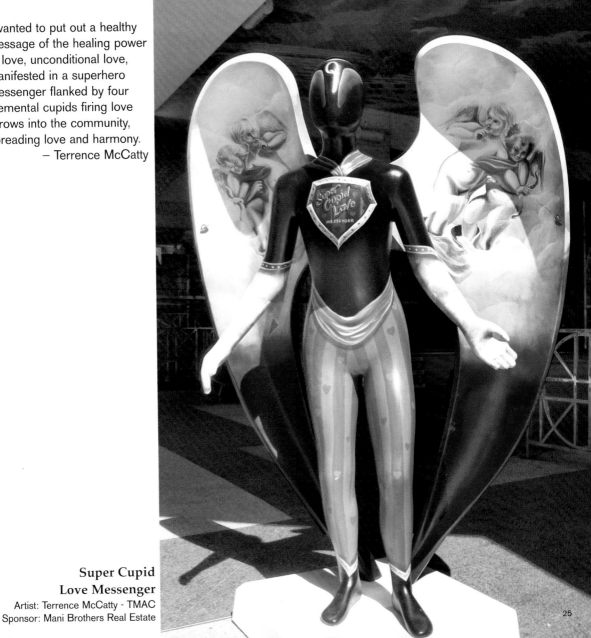

I wanted to put out a healthy message of the healing power of love, unconditional love, manifested in a superhero messenger flanked by four elemental cupids firing love arrows into the community, spreading love and harmony.

— Terrence McCatty

**Super Cupid
Love Messenger**
Artist: Terrence McCatty - TMAC
Sponsor: Mani Brothers Real Estate

25

The angel Moments Longing was inspired through the intent of healing balance . . . created in a private studio retreat nestled in a mystic oak chaparral valley of Southern California . . . a sanctuary removed from technological stimulus and sheltered by nature's treasures . . .

Moments Longing
to share
A gift from a Piece of Me
to inspire a gift
for a Peace in You.
— Trisha Lackey

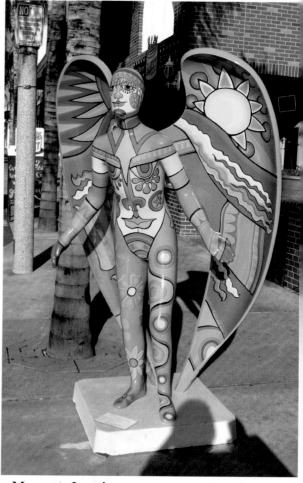

Moments Longing
Artist: Trisha Lackey
Sponsor: Alhambra Business District Association

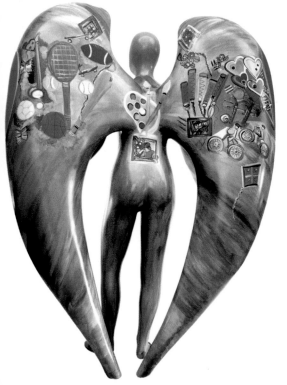

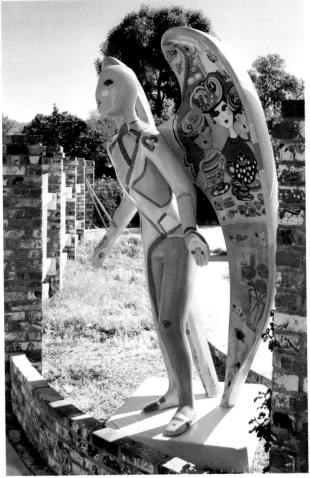

Joie de Vivre
Artist: Barbara Katz Bierman
Sponsor: Artful Children

27

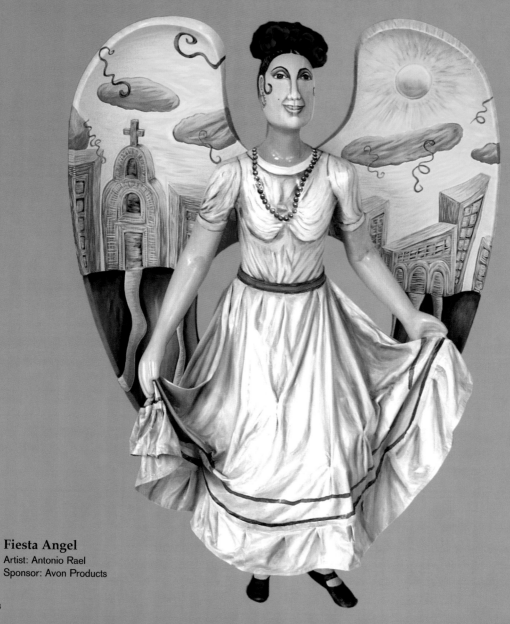

Fiesta Angel
Artist: Antonio Rael
Sponsor: Avon Products

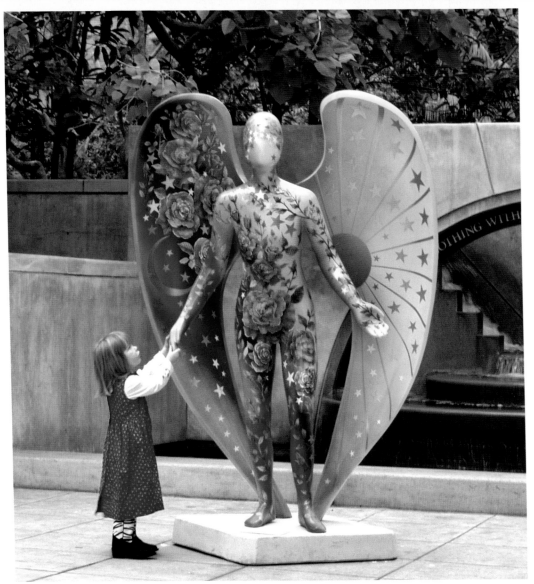

The Angel of Life
Artist: Raul R. Rodriguez
Sponsor: Recording for the Blind & Dyslexic

ARTISTS ON ANGELS

I believe they are in our midst. The good and beautiful souls are quietly working among us.

— Dori Atlantis

Angels are spirits, and each of us has his or her own. At least I do. I talk to him from time to time. Actually he started me painting. I was four years old and I didn't even know what paint meant.

— Beso Kazaishvili

I see angels as muses who carry us on their wings. They inspire us and protect us. I grew up with the reality of angels. Guardian angels were always with me.

— Saule Piktys-Zukerman

Young or old, fat or thin, male or female, each one of us should look into a mirror and see one of God's angels looking back.

— Alan Papaleo

I actually *did* see an angel once, when I was six years old. The angel was as clear as a bell, and I could paint *her* even today, decades later! However, I never told anyone about this because on the few occasions that I did, I got strangely sympathetic looks. Like, poor girl . . . deluded. Anyway, maybe this project will allow all of us to come out of the closet with our stories—do you think?

— Valerie Nielsen-Mendez

To not believe in angels is not to believe in ourselves.
— Silvia Wagensberg

When I was giving birth to our son I went into cardiac arrest. I heard them say they were losing me. I floated away and ended up in a long hallway, feeling beckoned towards a door with a bright light. On the walls were paintings I hadn't painted yet. I started to walk, but a small child tugged on my robe and said "You're going the wrong way." Then I woke up. My husband said I was gone over a minute. After my son was born I started exhibiting and did thirty paintings about angels.
— Jodi Bonassi

I have it from a good source that there are angels. While working on my angel in California Plaza, I was assured by an old woman I had a real angel with me . . . I turned to look at the painted angel and she said, "No, not that one."
— Dana Torrey

I believe there are spiritual angels that guide us in sometimes very subtle ways, and I believe in human angels that encourage, inspire and teach us daily or through the course of our lives! You gotta believe!
— Cathi Hagerty

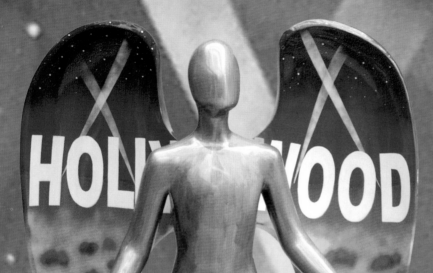

Hollywood Angel
Artist: Wim Griffith
Sponsor: McCarthy Cook & Co.

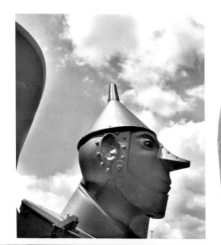

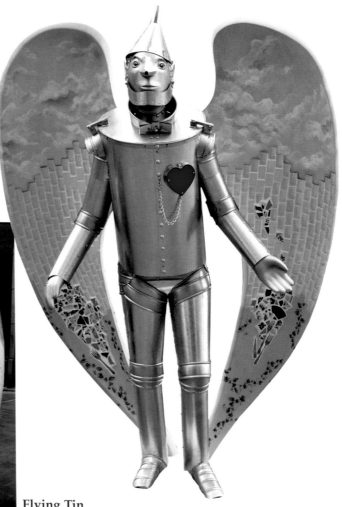

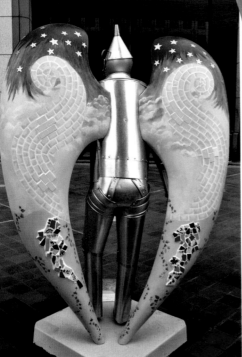

Flying Tin
Artist: Christine Mallouf
Sponsor: KLM Foundation

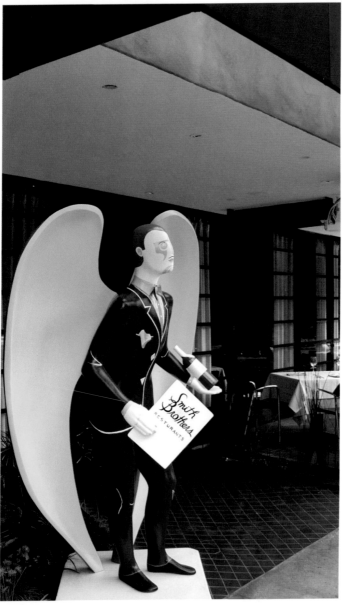

Oscar's Angel donned his tuxedo and took his position high above the Shrine Auditorium just in time to greet the cavalcade of stars arriving at the 73rd Annual Academy Awards

Oscar's Angel ▶
Artist: Academy Awards Production Crew
Sponsor: Academy of Motion Pictures Arts & Sciences

Bon Appetit
Artist: Tony Sheets
Sponsor: Smith Brothers Restaurants

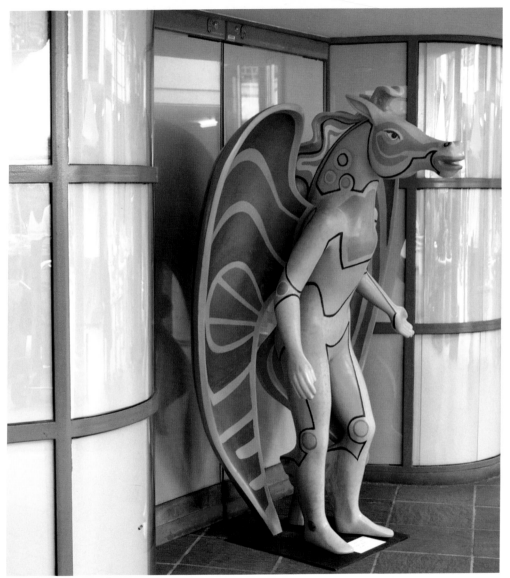

Starlight Expression
Artist: Tony Sheets
Sponsor: Tony Sheets

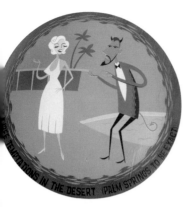

Our concept was to depict an apocalyptic battle featuring old Hollywood stars and angelic/demonic cats, done with humor.

– Shag

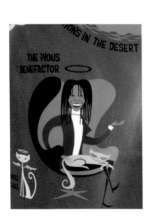

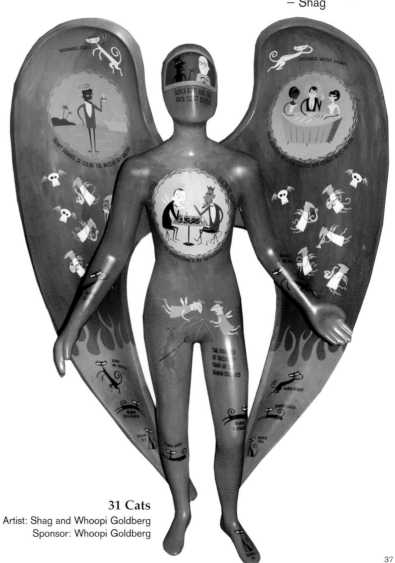

31 Cats
Artist: Shag and Whoopi Goldberg
Sponsor: Whoopi Goldberg

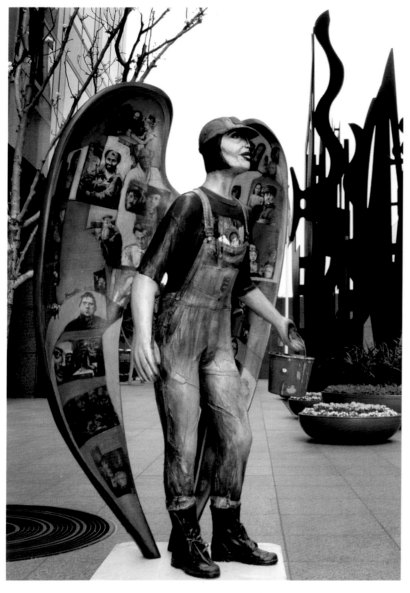

The inspiration behind the design of my angel is the idea that we are all angels, appearing in each others' lives when we are in need of learning something from each other, or teaching someone something, or loving someone.

— Danuta Rothschild

Marilyn ▶
(work in progress)
Artist: Steve Kaufman

The Artist

Artist: Danuta Rothschild
Sponsor: Walter Lantz Foundation

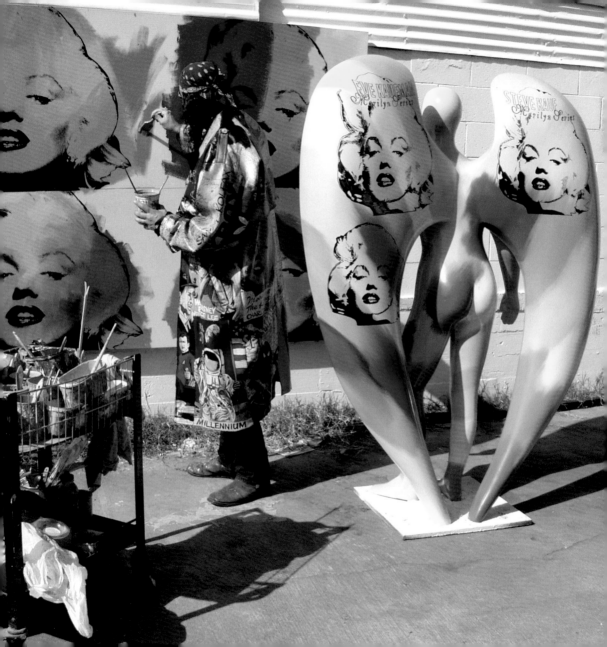

More Than Shelter
Artist: Paula Van Horn and Dan Van Clapp
Sponsor: Century Housing

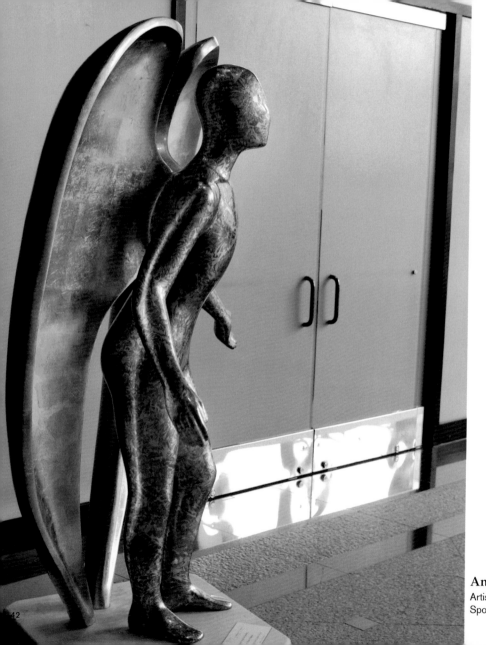

Angel of Healing
Artist: Victor Raphael
Sponsor: Peet's Coffee & Tea

I have created a previous body of figurative works, which are part of my "Archetypes of the Feminine" series. The angel intrigued me because she was three-dimensional. Being a collage artist, I approached her with layers of paper, paint and found materials, the way I would approach a canvas.

– Susan Krieg

Archetype of the Feminine
Artist: Susan Krieg
Sponsor: Wilshire Grand Hotel

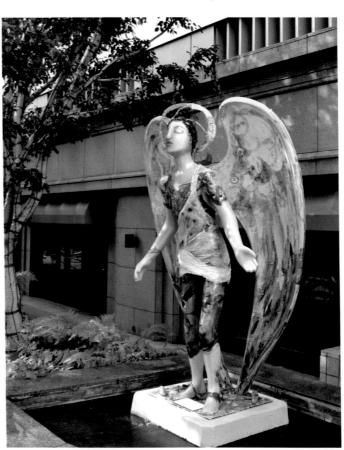

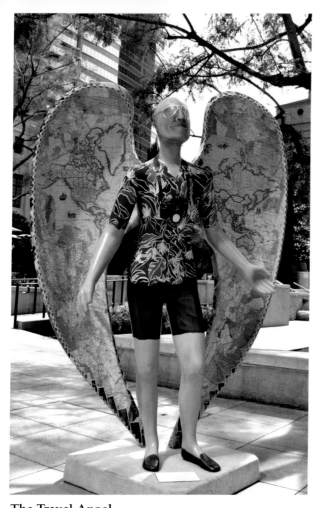

We thought about all the angels that travel with us, and how they might like to visit some places when they are not working—when they are just on vacation. From this, came the idea of The Travel Angel. He appears in "local attire" in an effort to blend in with those people living here. His wings are "feathered" with postcards and travel stickers from the many places he has visited. All add to his knowledge of the "human experience."

– Dean and Laura Larson

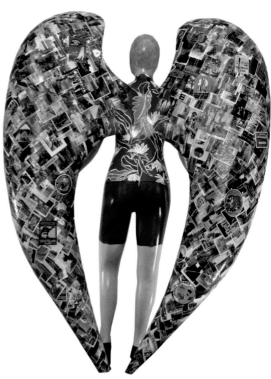

The Travel Angel

Artist: Dean and Laura Larson
Sponsor: LA Convention & Visitors Bureau

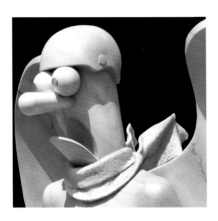

The Reluctant Angel bears an amazing resemblance to Bunsen Honeydew's scientific assistant / foil on "Muppets Tonight." If Beaker also wears size-14 sneakers, The Reluctant Angel is surely Beaker in disguise.

Beaker Profile

Special Talents:
Scientific Victim

Quote:
"Meep! Meep! Meep!"

Never Leaves Home Without:
Medical Coverage

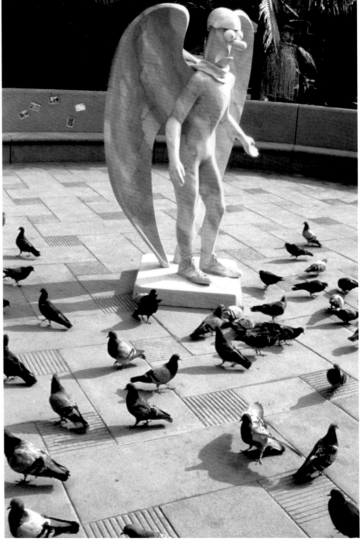

The Reluctant Angel
Artist: Jim Henson's Creature Shop™ Edward C. Eyth, Art Director
Sponsor: The Jim Henson Company

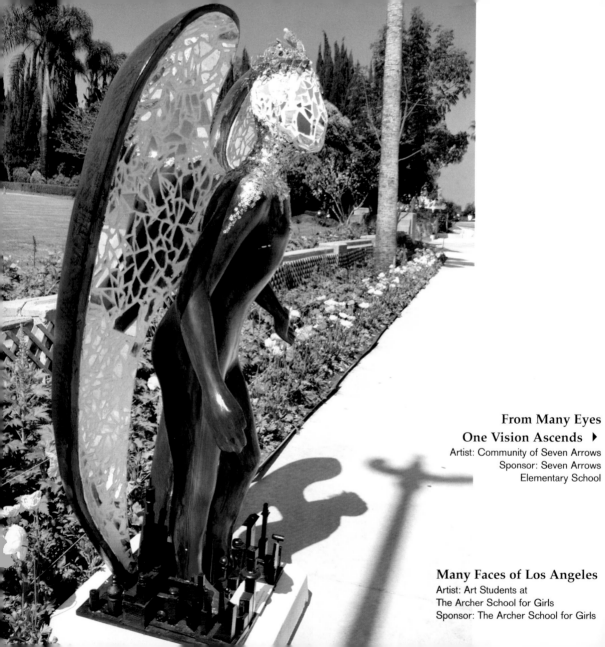

**From Many Eyes
One Vision Ascends** ▸
Artist: Community of Seven Arrows
Sponsor: Seven Arrows
Elementary School

Many Faces of Los Angeles
Artist: Art Students at
The Archer School for Girls
Sponsor: The Archer School for Girls

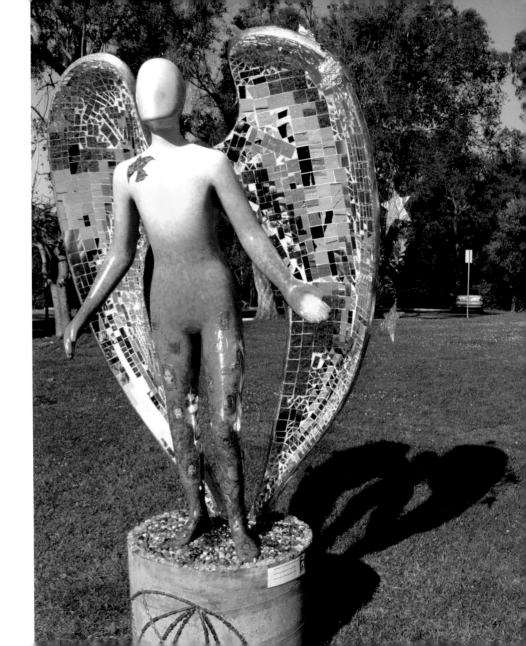

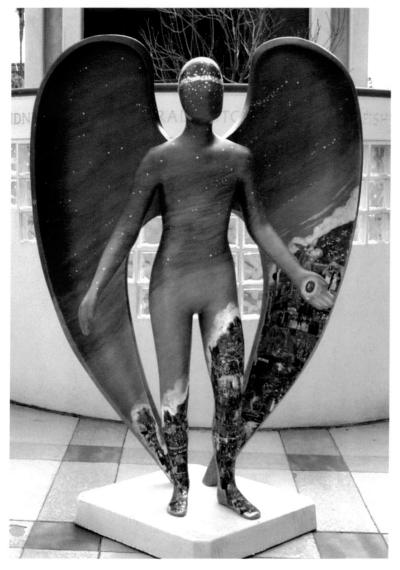

St. Vincent Medical Center, run by the Daughters of Charity, takes care of the poor and indigent peoples of Los Angeles, with a particular mission of attending to AIDS victims. Since it is located in the heart of the city, I chose cityscapes supported and surrounded by angels.

— Valerie Nielsen-Mendez

The Bay Keeper ▶
Artist: Kirtland Ash
Sponsor: Santa Monica BayKeeper

City of the Angels
Artist: Valerie Nielsen-Mendez
Sponsor: St. Vincent Medical Center

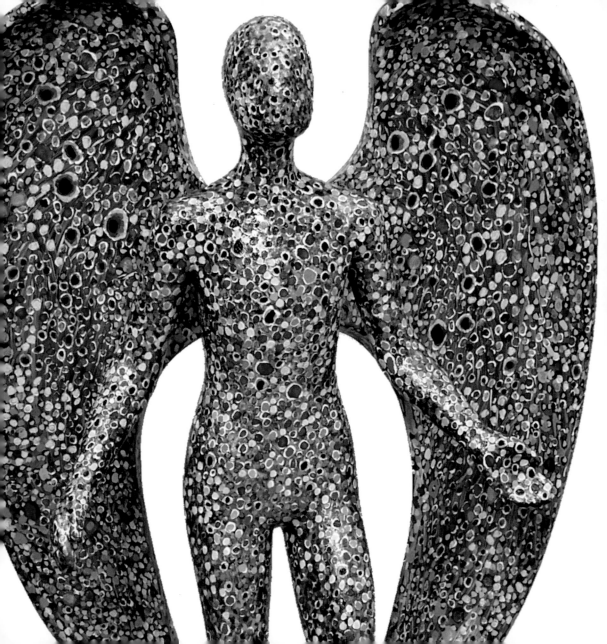

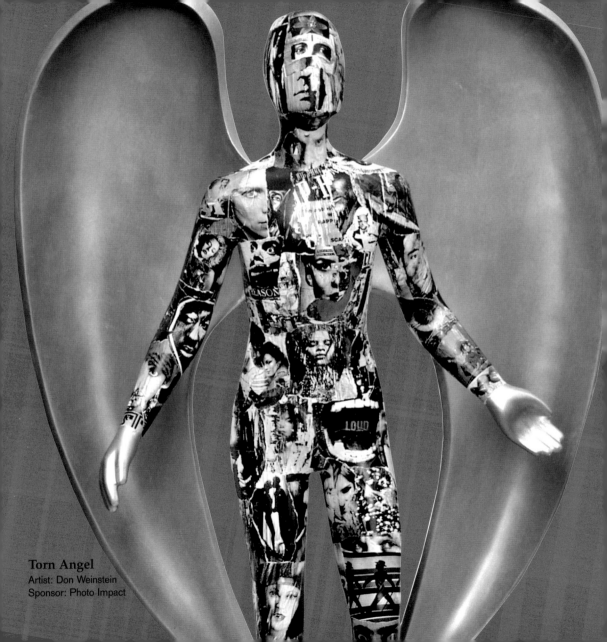

Torn Angel
Artist: Don Weinstein
Sponsor: Photo Impact

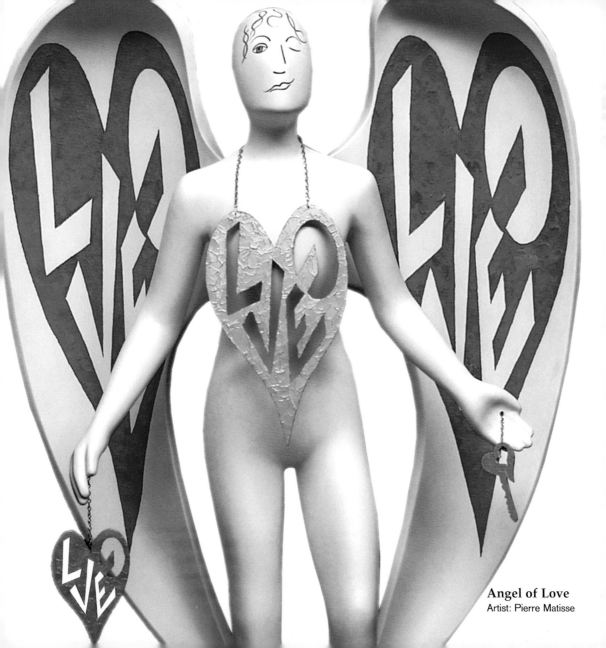

Angel of Love
Artist: Pierre Matisse

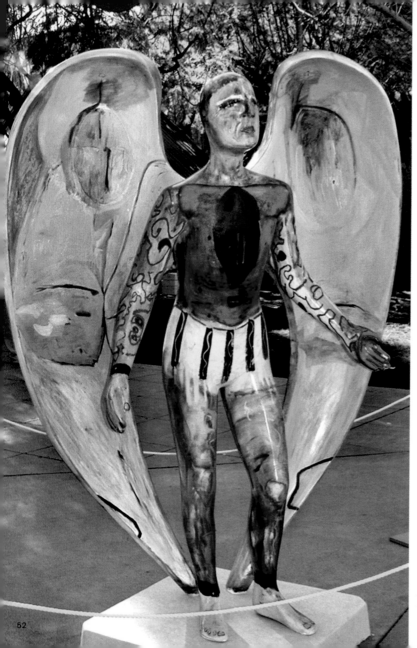

Compassion
Artist: Joshua Elias
Sponsor: SRO Housing

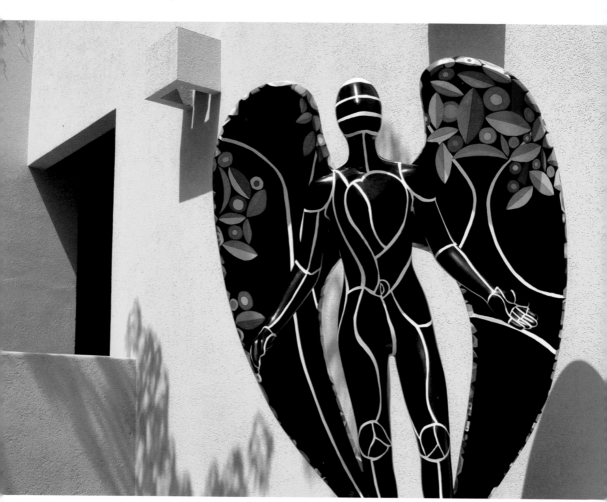

Davi and the Eyes of Horus
Artist: Daryn Berman
Sponsor: Camp Del Corazon

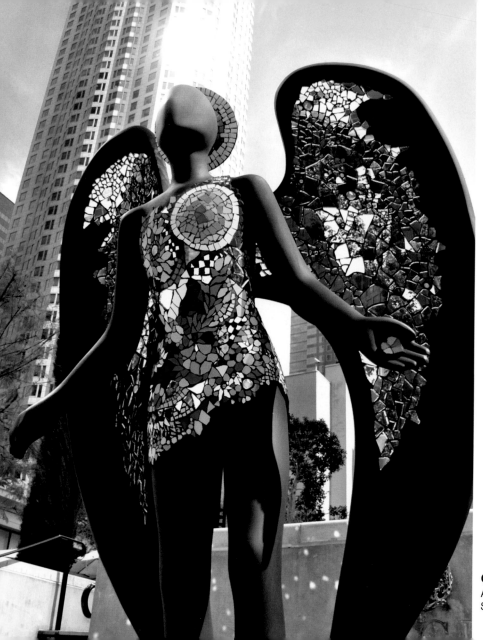

I want LA to see itself in the mirrored wings as it will reflect our wonderfully diverse city and give us the chance to ponder our own images as well as our community's.
— Melinda Moore

Quintessence
Artist: Melinda Moore
Sponsor: PinnacleOne

Angel of Music is designed to embody the joyousness and healing qualities that are inherent in music, an art that unites peoples around the world, and especially to inspire and educate children of all ages to participate in making music. A song I wrote called "Angel of Music" plays from the base. The song is written out in full, in hearts, on the back of the wings to spur people to sing along.
– Carol Worthey

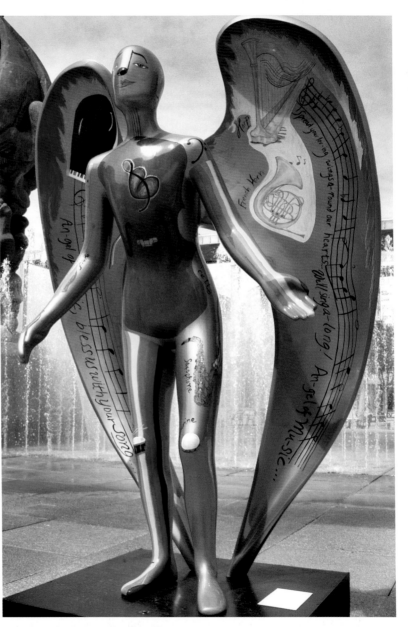

Angel of Music
Artist: Carol Worthey
Sponsor: Mu Phi Epsilon,
 San Fernando Valley Alumni Chapter

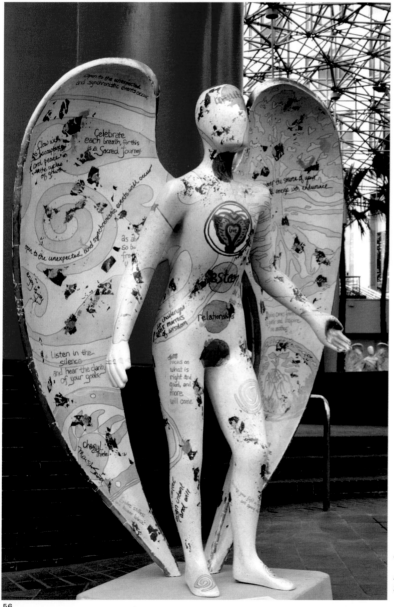

The theme of The Angel's Journey is universal spirituality and the paths that individuals take as they grow, evolve and live life. By blending a combination of symbolic designs, colorful illuminations at the energy centers and intuitive written messages, this angel is indeed on a journey. A journey to wisdom, integrity, openness and inner peace.
 — Marsh Scott and Cheryl Thiele

The Angel's Journey
Artist: Marsh Scott and Cheryl Thiele
Sponsor: AmericanSingles.com

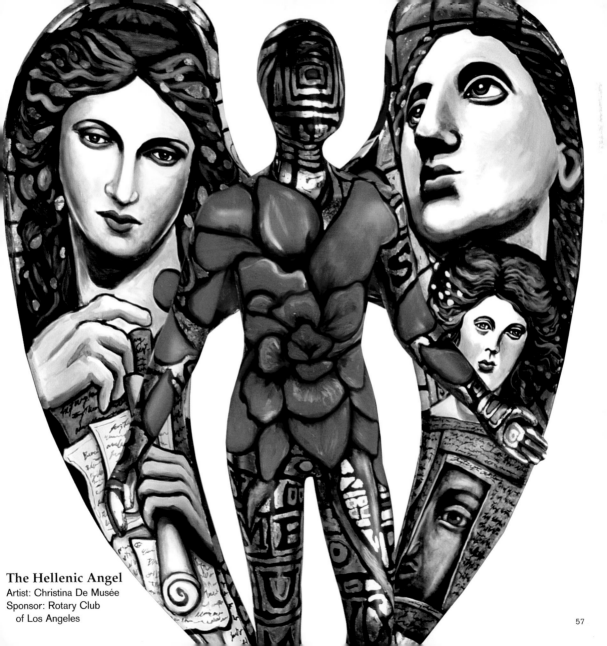

The Hellenic Angel
Artist: Christina De Musée
Sponsor: Rotary Club
of Los Angeles

57

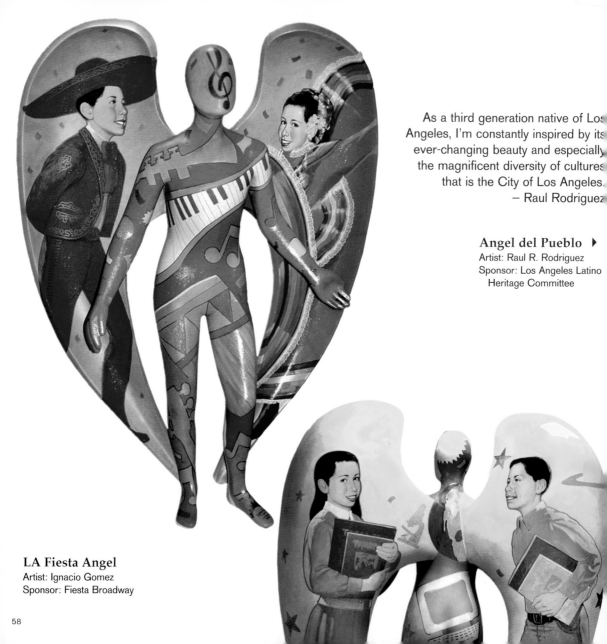

As a third generation native of Los Angeles, I'm constantly inspired by its ever-changing beauty and especially the magnificent diversity of cultures that is the City of Los Angeles.
— Raul Rodriguez

Angel del Pueblo ▶
Artist: Raul R. Rodriguez
Sponsor: Los Angeles Latino Heritage Committee

LA Fiesta Angel
Artist: Ignacio Gomez
Sponsor: Fiesta Broadway

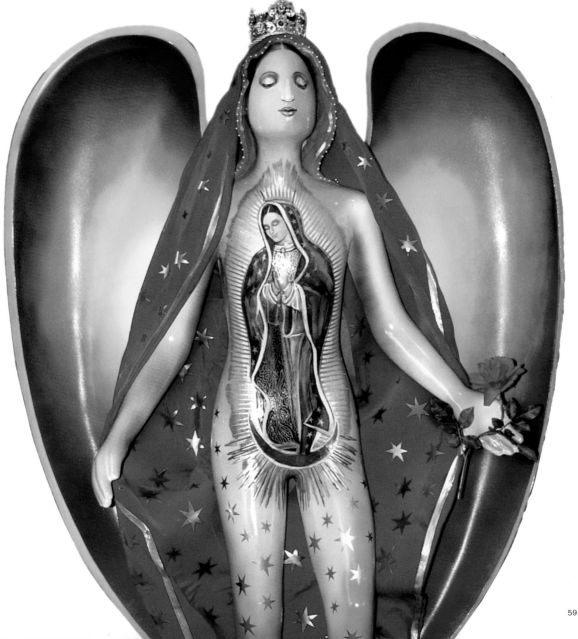

ANGELS ON ARTISTS

I believe that this angel sculpture has given me the opportunity to do something that angels are meant to do, which is to bring a feeling of self-worth, excitement, wonder and connectedness to the six children who painted the butterflies upon it. These children knew they were participating in a larger-than-life experience and they rose to the occasion.

— Susan Reichman

I have never felt so much peace and calmness in my heart as while decorating my angel.

— Teresita Bartolome

I had an unusual experience when I first started painting the ocean on the angel's feet and legs. I actually felt seasick and had to lie down. I guess I acclimated to the ocean because after a while it didn't bother me any more.

— Suzanne Rifkin

After unwrapping my angel from its protective cover, I put my arms around it and wept. It was a sensation of embracing a physical manifestation of the unseen.

— Doug Webb

I was continually in awe of my angel, as I watched her acquire her personality.

— Susan Krieg

One unique experience was that on the day after my mother came home from UCLA Hospital after cancer surgery, two angels were delivered. I think we both felt it was a good omen.

— Linnea Pergola

As I painted, I began to feel incredible peace and happiness. The painting took on depth and perception in the curves of the wings. I let the angel dictate to me how the artwork was to evolve.

— Janine Anderson

I felt a very special energy from my two angels—as if they were guiding me to go beyond my capabilities. I grew attached to them and needed very little sleep the time they were with me.

— Jodi Bonassi

I had no preconceived design or plan. My angel was delivered to my studio and the creation process took ten days. The process had a life of its own. This is when magic happens.

— Gayle Garner Roski

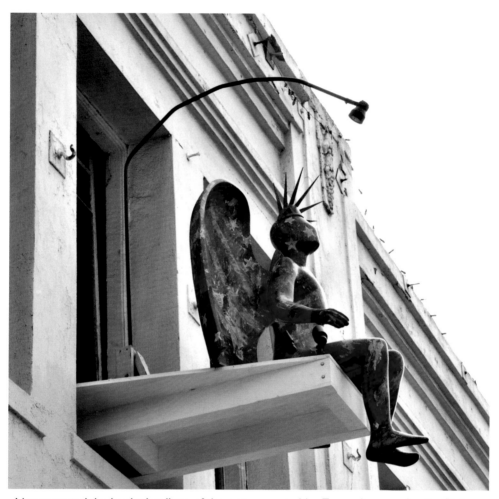

I incorporated the beginning lines of the poem created by Emma Lazarus for the Statue of Liberty because they suit our port city so well (the entry to the Port of LA is Angel's Gate): "Here at our sea-washed, sunset gates shall stand/A mighty woman with a torch, whose flame is the imprisoned lightning . . ."

— Janice Lloyd Govaerts

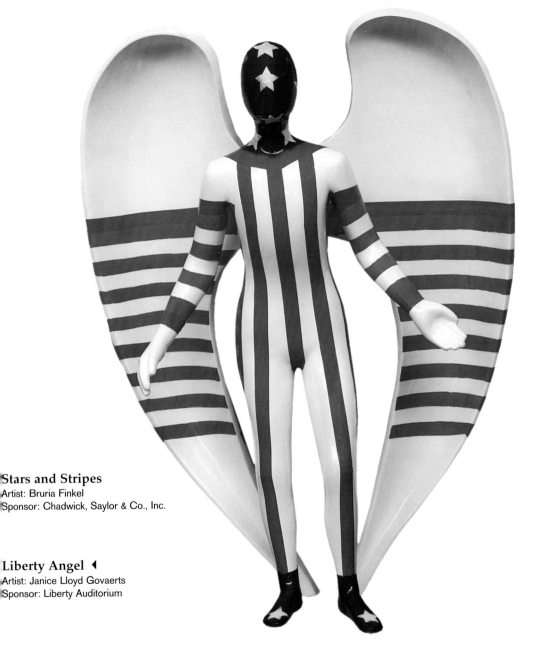

Stars and Stripes
Artist: Bruria Finkel
Sponsor: Chadwick, Saylor & Co., Inc.

Liberty Angel ◀
Artist: Janice Lloyd Govaerts
Sponsor: Liberty Auditorium

63

My interest is in social and ecological issues. It is always good to see people helping each other, volunteering and getting involved with making our cities more livable and our lives happier and more workable. This angel looks upon all the good that mankind can do if we just put our minds to it.

— Thomas Slagle

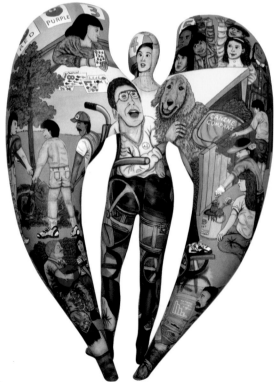

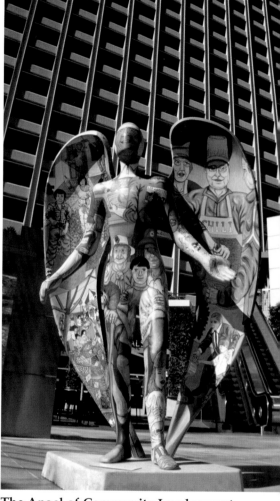

The Angel of Community Involvement and Volunteerism

Artist: Thomas Slagle
Sponsor: Union Bank of California Foundation

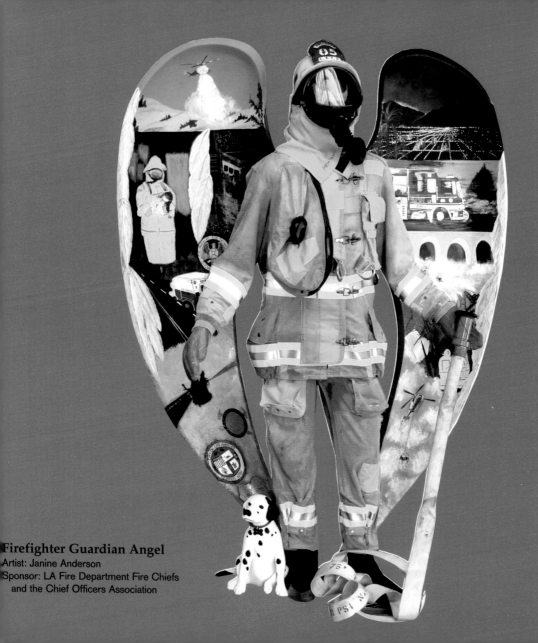

Firefighter Guardian Angel
Artist: Janine Anderson
Sponsor: LA Fire Department Fire Chiefs
and the Chief Officers Association

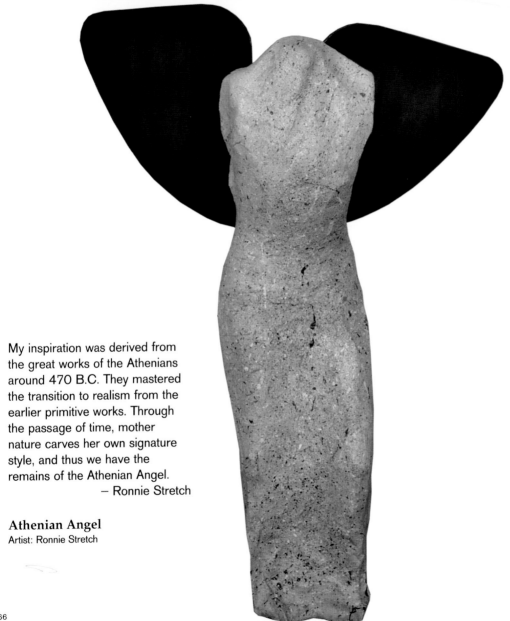

My inspiration was derived from the great works of the Athenians around 470 B.C. They mastered the transition to realism from the earlier primitive works. Through the passage of time, mother nature carves her own signature style, and thus we have the remains of the Athenian Angel.

— Ronnie Stretch

Athenian Angel
Artist: Ronnie Stretch

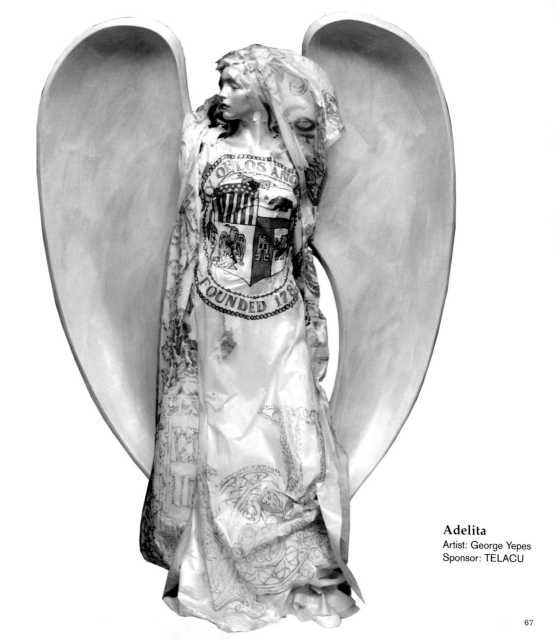

Adelita
Artist: George Yepes
Sponsor: TELACU

67

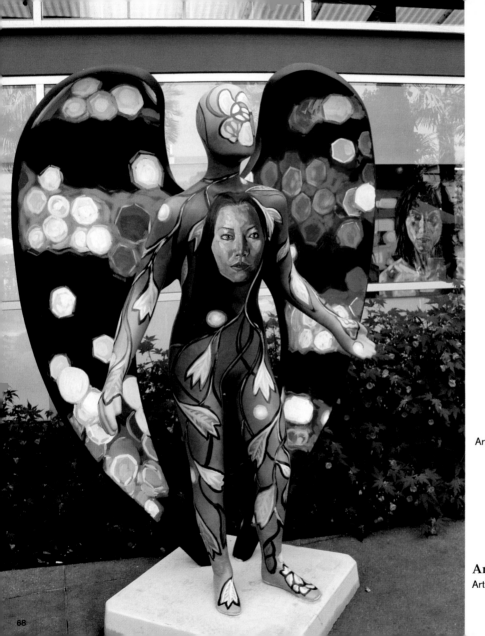

Earth Angel ▶
Artist: Valerie Nielsen-Mendez
Sponsor: National Institute
of Transplantation

Angel of the Elements
Artist: Miguel Angel Reyes

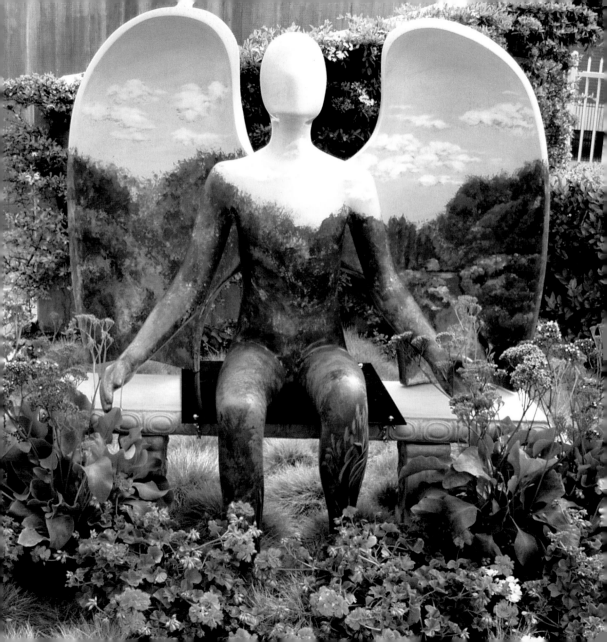

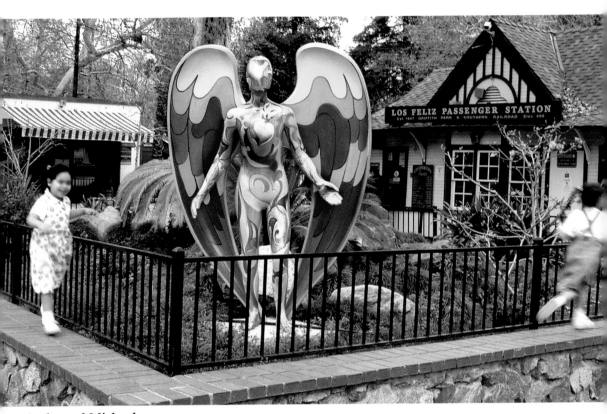

Archangel Michael
Artist: Ernesto de la Loza
Sponsor: The Griffith Park Train Rides

The sunburst is like the phoenix rising from the flames, and the universe on the back expresses the wonders and hope of the creation of new things in Los Angeles.

— Lura Schmiedeke and Jeannette Hay

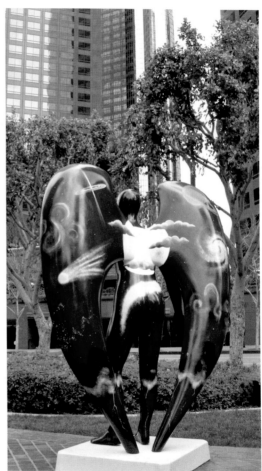

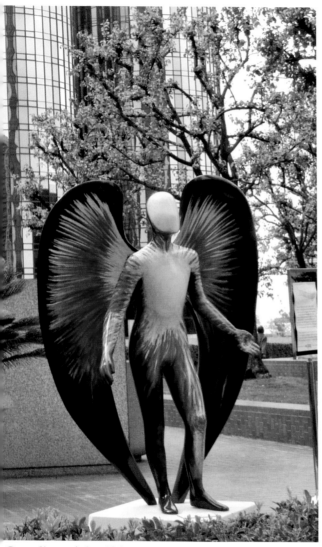

Guardian of the Skies
Artist: Lura Schmeideke and Jeannette Hay
Sponsor: Sheppard, Mullin, Richter & Hampton, LLP

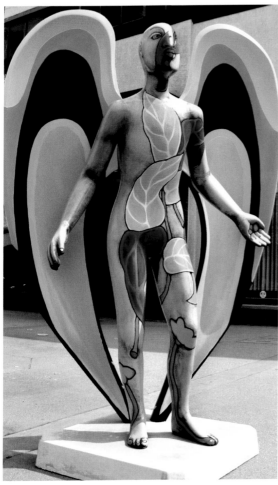

It was important for me to use color, shape and form to portray, better than words ever could, the impossible but tangible fantasy of a garden paradise.

— Silvia Wagensberg

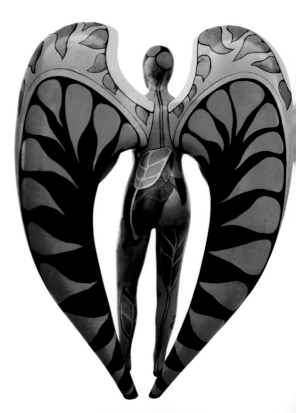

Garden Angel
Artist: Silvia Wagensberg
Sponsor: Alhambra Central Business District Association

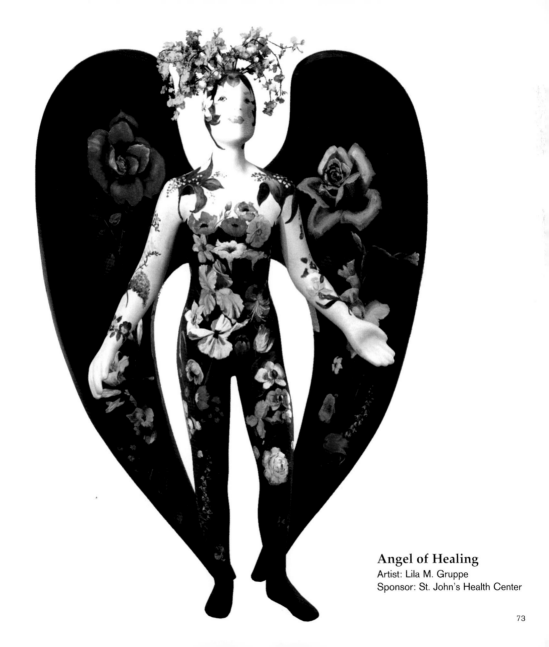

Angel of Healing
Artist: Lila M. Gruppe
Sponsor: St. John's Health Center

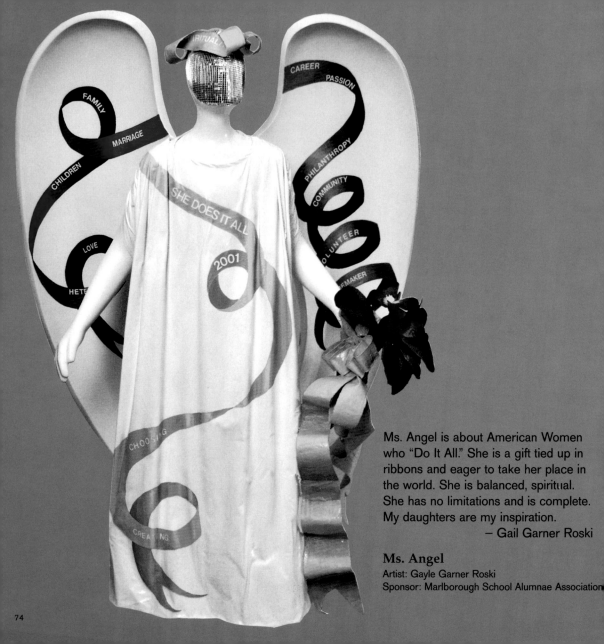

Ms. Angel is about American Women who "Do It All." She is a gift tied up in ribbons and eager to take her place in the world. She is balanced, spiritual. She has no limitations and is complete. My daughters are my inspiration.

— Gail Garner Roski

Ms. Angel
Artist: Gayle Garner Roski
Sponsor: Marlborough School Alumnae Association

74

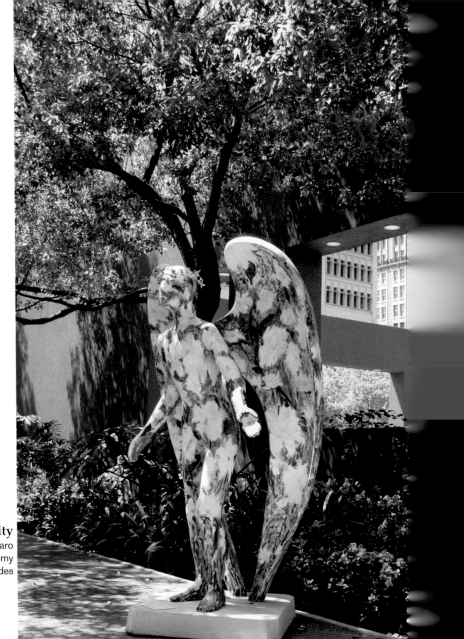

Flora Gorgeosity
Artist: Linda Vaccaro
Sponsor: The Alexandria Academy
and Lyle Brandes

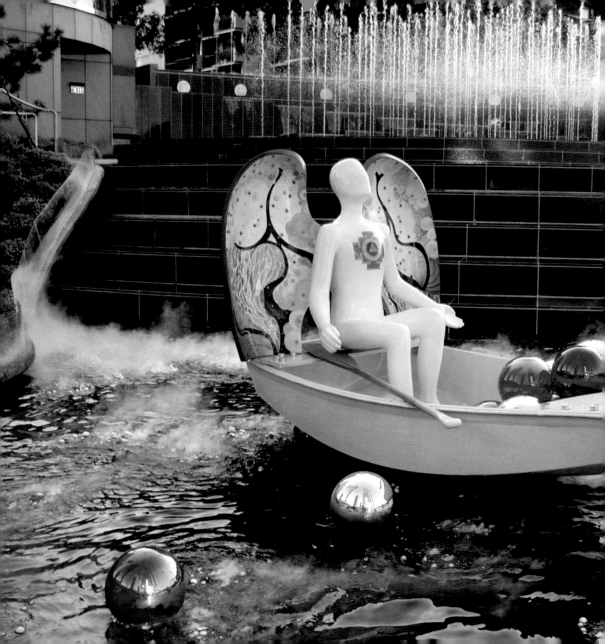

I, O Lord, shall lead (beings) across
the great flood of their diverse fears;
Therefore the eminent seers sing
of me in the world by the name of Tara.

— The Hundred and Eight Names of the Venerable Tara
spoken by the illustrious Lord Avalokita

This angel is adorned in the Tantric symbol of Tara.
By tradition, Tara is the goddess of compassion
who removes fear and obstacles across relative
water passages. She is connected to speech and
guards the pond of nectar. Thus she is the ferry
woman between planes of existence.

— Stephen Schubert

Tara
Artist: Stephen Schubert
Sponsor: The Witherbee Foundation

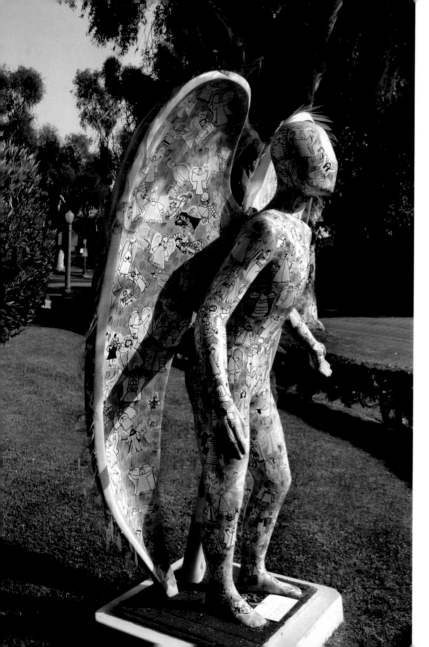

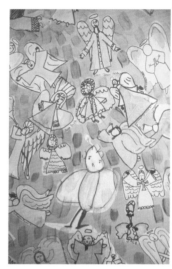

The Gift of Life Angel ▶
Artist: Karen Fredrickson
Sponsor: Transplant Recipients
 International Organization–
 Ventura County West Valley Chapter

A Child's View
Artist: Cami, Kathy, Melisa
and the Corpus Christi Kids
Sponsor: Corpus Christi Church

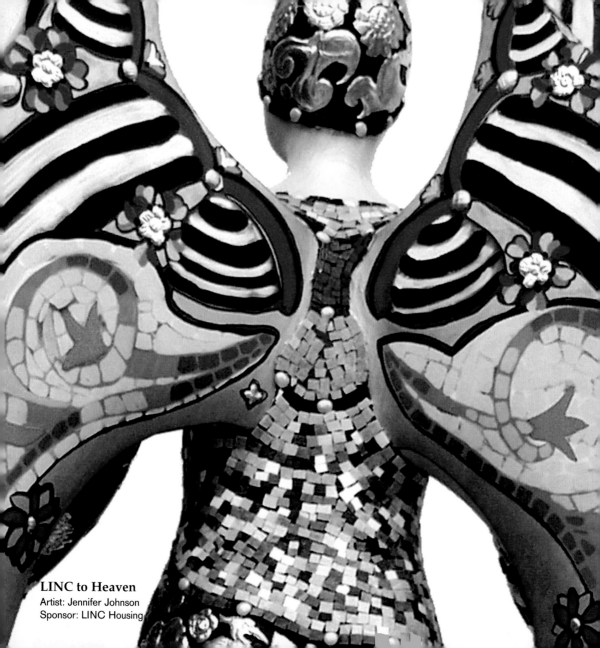

LINC to Heaven
Artist: Jennifer Johnson
Sponsor: LINC Housing

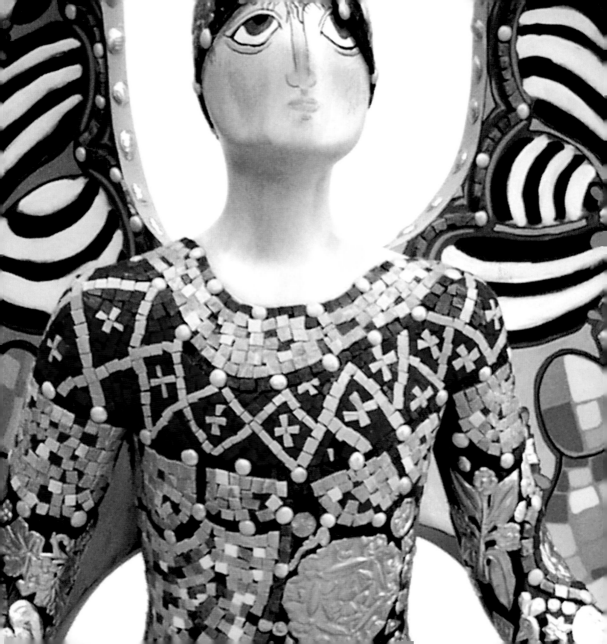

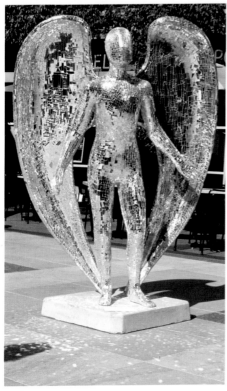

I would like the angel to reflect and represent a diverse group of people and backgrounds. Hence the flags on the back of the angel's wings. By looking at the angel Reflections, people will literally see an angel within themselves.

— Teresita Bartolome

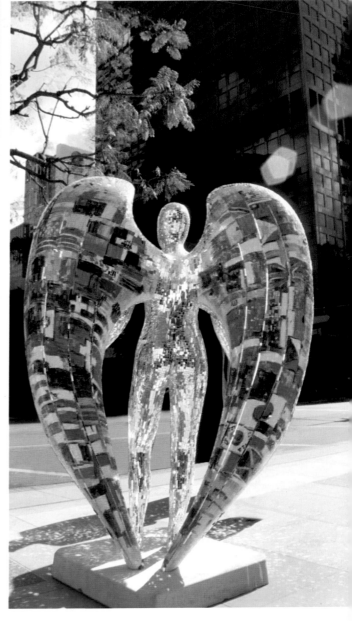

The Glittering Angel reflects LA's diverse population and geography. The glass mosaics on the wings mirror our brilliant sky, the sparkling ocean and snow-topped mountains. The swirling gold and silver body paint celebrates the many cultures intertwined throughout Los Angeles.

— Sue Keane

Glittering Angel
Artist: Sue Keane
Sponsor: Westwood Village Sertoma Club

Reflections ◀
Artist: Teresita Bartolome
 (assisted by Corregidor Lions Club
 members, SCE engineering employees,
 Willowood School Teachers)
Sponsor: Bart and Kelly Pucci

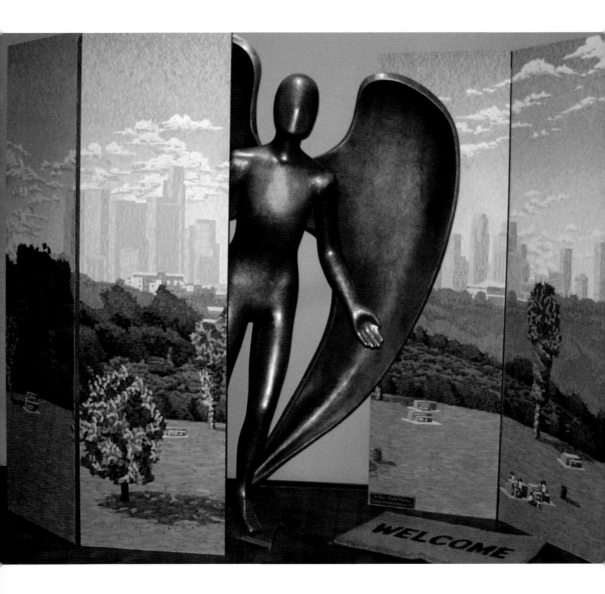

Paulist Productions made a film called *Entertaining Angels: The Dorothy Day Story* about the founder of the Catholic Worker movement. She welcomed and ministered to the poor through houses of hospitality. Cynthia Wuliger and her art students worked with this hospitality theme to create Entertaining Angels.

— Frank Desiderio, C.S.P.

Entertaining Angels
Artist: Cynthia Wuliger /
Children of St. Paul the Apostle School
Sponsor: Paulist Productions

City of Angels ◀
Artist: Dana Torrey
Sponsor: The Wallis Foundation

Some of the people I've worked with often seem like angels to me because of their level of dedication and involvement in community projects. We Are All Angels honors the everyday angels. We all have this possibility inside of us.

— Sarajo Frieden

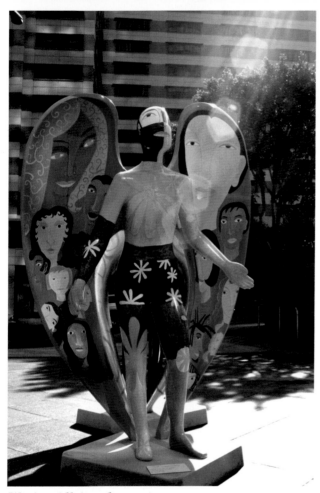

We Are All Angels
Artist: Sarajo Frieden
Sponsor: BP

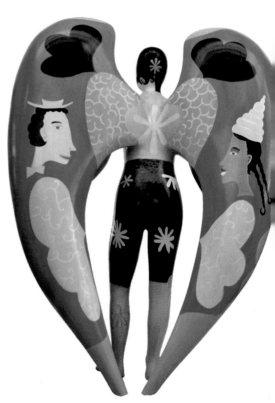

Sirin ▶
Artist: Susan Fairbairn
Sponsor: Marlborough School
Alumnae Association

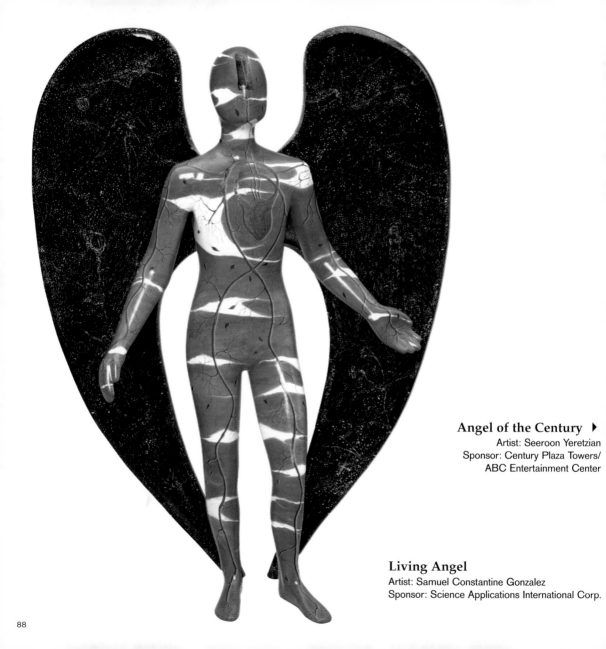

Angel of the Century ▶
Artist: Seeroon Yeretzian
Sponsor: Century Plaza Towers/
ABC Entertainment Center

Living Angel
Artist: Samuel Constantine Gonzalez
Sponsor: Science Applications International Corp.

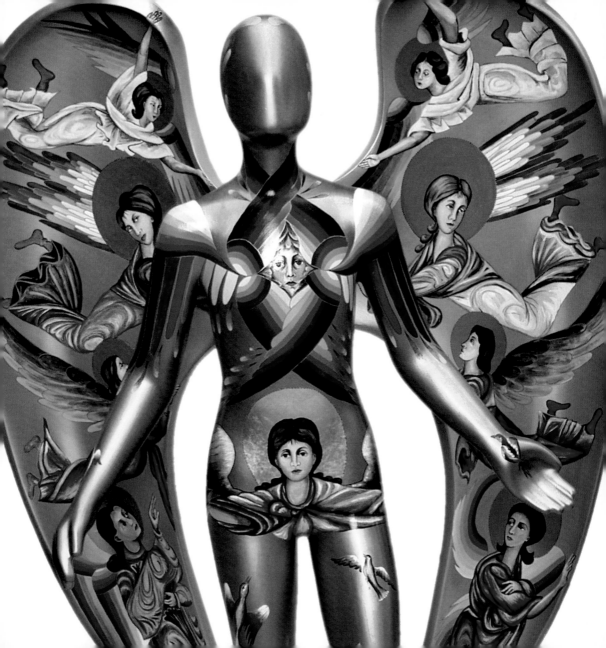

ANGELS ON ANGELENOS

We were rolling Pennies from Heaven through the garage of the bank to put it on display and passed a parking attendant. Upon seeing it, he took a step back and instantly crossed himself twice. I realized at that moment the unknown power of the image of an angel.

— Scott Berg

Our participation in the Community of Angels project was motivated by several factors: The desire to display "real" art in a location where it will be viewed by thousands of children from all economic situations every month. The desire to participate in a city-wide community effort that might in some small way help bring the city closer together. The wish to help valuable charities such as Volunteers of America and Catholic Big Brothers. And finally, a love of accessible art.

— Sponsors Don and Peggy Gustavson
(The Griffith Park Train Rides)

I visited the Glendale Galleria a couple of weeks after I had completed my angel there, and sat quietly in the coffee shop to observe the reaction of the people to the angel. I remember one family with kids approaching the artwork in deep reverance, as if entering a church. The little kids tiptoed across the fence to touch the angel, with an expressions on their faces as if a miracle were about to happen!

— Susi Galloway

It happened on a rainy Sunday evening while I was working on my angel in the garage . . . the door was open and I stood by her side . . .capturing the "moments" and "longing" to breathe in the freshness of the earth's cleansing rains. Unexpectedly, a small car drove up, and out rushed a neighbor I had only briefly met. She entered the garage, enfolded her chest with her arms, and softly spoke: "I really needed to see an angel." I listened with wonder, but no words. And the rain continued to flood the emotions of us both.

— Trisha Lackey

When we finished painting the angel, the six children, myself and the other two group facilitators joined hands in a circle around it and together we said, "We are important and we can do wonderful things!"

— Susan Reichman

Whenever people saw our angel, it did not matter what kind of day they had had, because when they saw her, they immediately smiled and wanted to come over and touch her and hang around her. Many people would go and get their cameras, come back and take photos. She seemed to make everyone who saw her happier.

— Lura Schmiedeke and Jeannette Hay

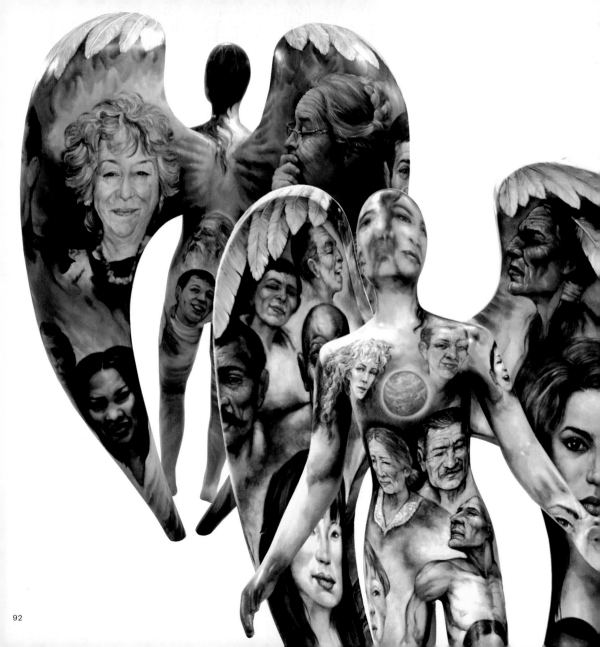

In my twenties I was a vagabond and world traveler. I liked to look at maps of the world and faraway places. I always thought "other places" were more exciting and exotic. I have had dreams and within them I am flying above the earth with angels. I have a smile on my face. Aren't dreams great?
— Michael Pedziwiatr

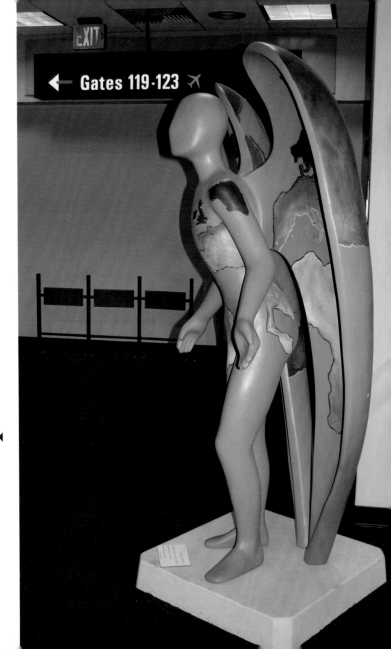

Angels in a Crowd ◀
Artist: Eddie Lopez
Sponsor: AMS Response

Bringing the World Together
Artist: Michael Pedziwiatr
Sponsor: British Airways

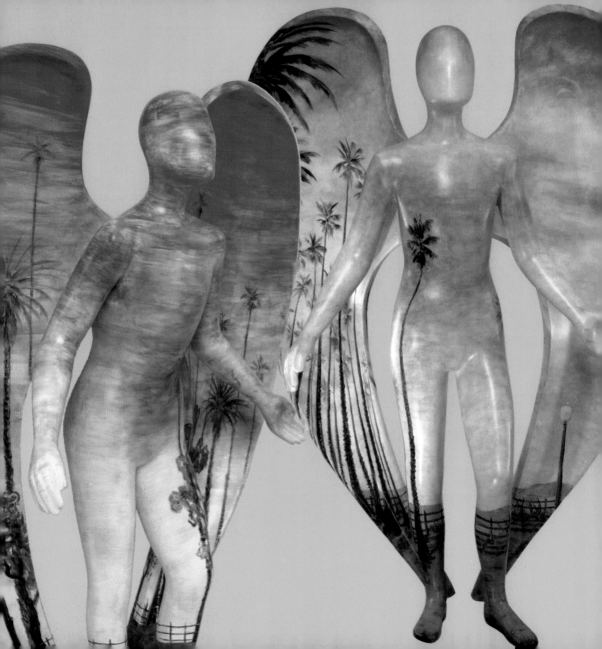

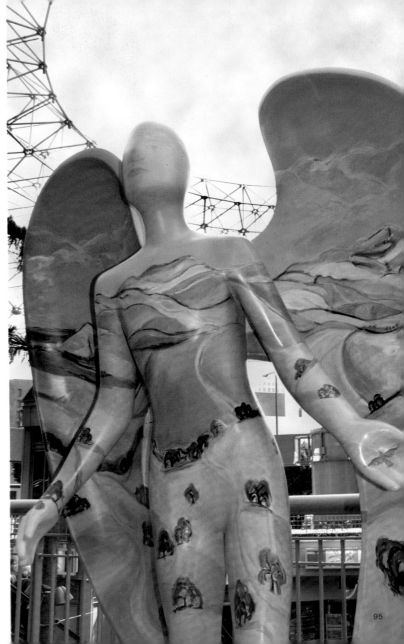

Angelscape suggests that the natural landscape is heaven on earth. The angel's surface is completely covered with a California landscape, Sedgwick Ranch, a nature preserve in the Santa Ynez Valley.
— Gwen Cates

Angelscape
Artist: Gwen Cates
Sponsor: William Morris Agency

What better way to symbolize our city than images of the most beautiful views our city has to offer? As a transplanted New Yorker, I've always been inspired by the warm weather, landscape, the palm trees, the blue sky and ocean, all of which to me exemplify my ideal of LA.
- Barbara Ashton

Palisades Angel ◀
Artist: Barbara Ashton
Sponsor: Sidley & Austin

Angel Dusk ◀
Artist: Barbara Ashton
Sponsor: Reish Luftman
 McDaniel & Reicher, a PC

95

I remember my first visit to the observatory at night, looking at all the sparkles of the city lights. I found it incredibly beautiful. That was twenty-one years ago. Since then I have traveled to and lived in many other places, but I still feel this fascination with LA's night skies, the high palm trees . . . and it is this image that came to mind when I sat down to do my sketch for Angelus Nocturnus.

— Susi Galloway

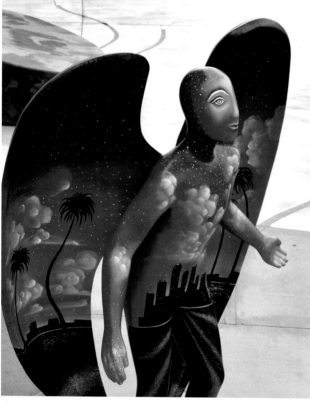

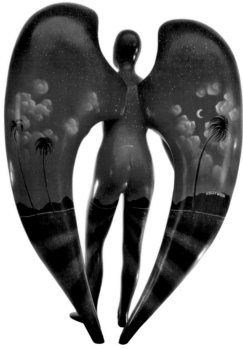

Angelus Nocturnus
Artist: Susi Galloway
Sponsor: Los Angeles Convention & Visitors Bureau

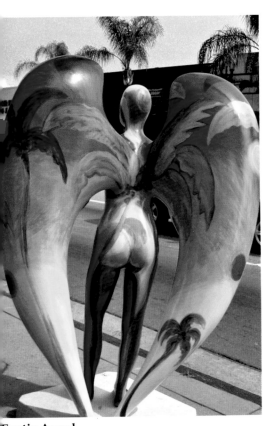

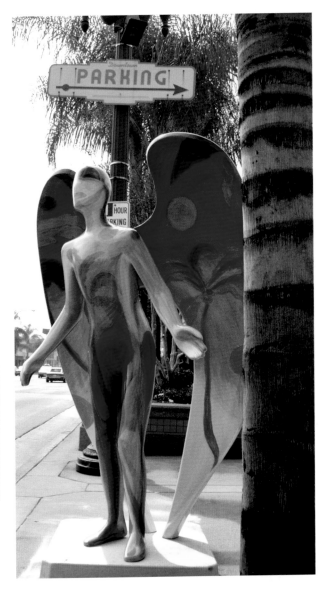

Exotic Angel
Artist: Michael Falzone
Sponsor: Alhambra Central Business District Association

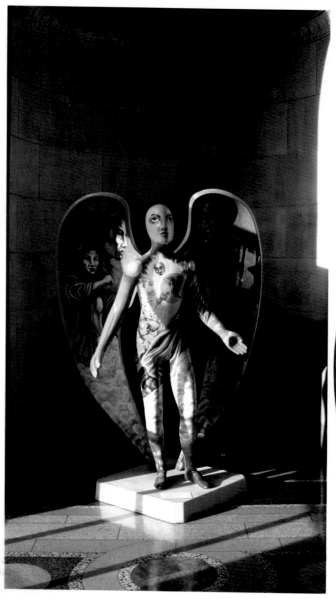

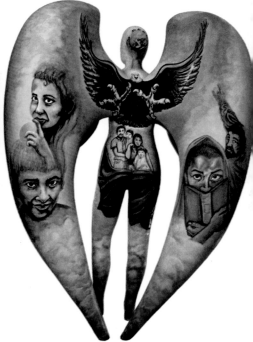

My Angels Over LA theme came to me in the night, perhaps whispered into my ear by an angel. I could picture the illuminated skyline of LA in the night with buildings aglow. I could also imagine angels flying through the stars, clouds and moonlight. The angels were beautifully colored red, white, brown, black and yellow signifying the diverse ethnicity of the city's culture.

— Linda Zaiser

Angels Over LA
Artist: Linda Zaiser
Sponsor: U.S. Trust Compnay

Angel of Vision ◀
Artist: Eddie Rodriguez
Sponsor: El Arca

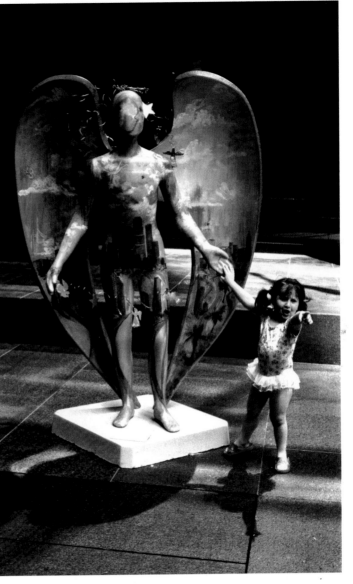

I was born in Moscow and immigrated to Los Angeles twenty years ago. For me, the City of Angels represented freedom of expression and freedom from fear. The Freedom Angel is opening his wings to everyone—he is color- and agenda-blind.

— Natasha Landau

Freedom Angel
Artist: Natasha Landau
Sponsor: Jones, Day, Reavis & Pogue

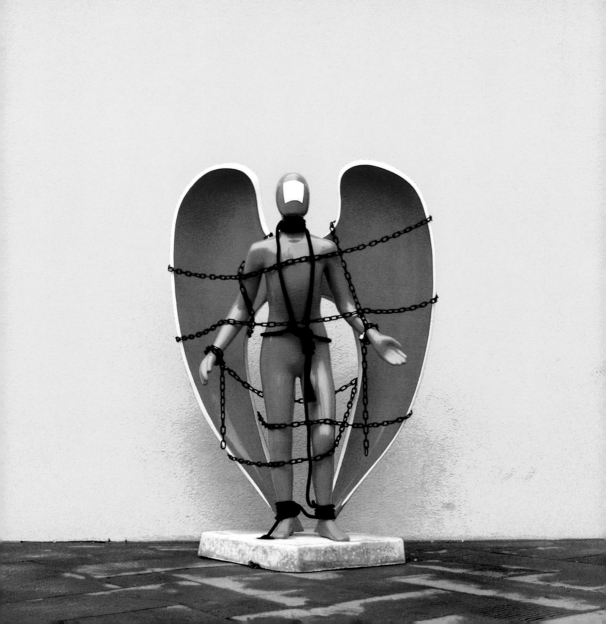

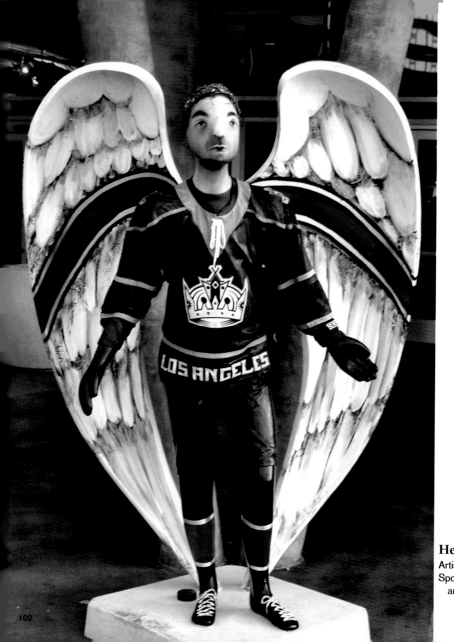

He's No Angel, He's a King
Artist: Susan Krieg
Sponsor: STAPLES Center Foundation
 and Kings Care Foundation

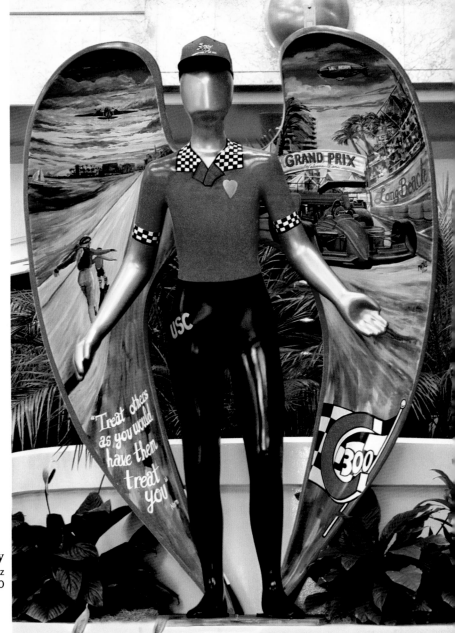

Serendipity
Artist: Daniel Martinez
Sponsor: Committee of 300

Earth Angel
Artist: Eddie Lopez
Sponsor: Transamerica

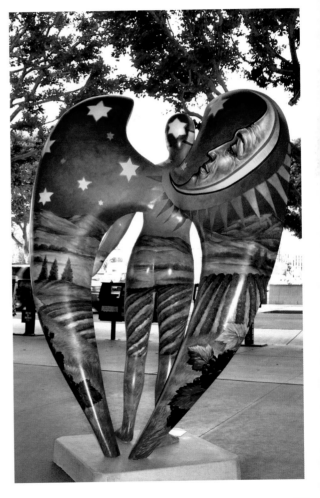

Angel on the Green ◀
Artist: Janine Anderson
Sponsor: Past Presidents of Catholic Big Brothers;
Rick Higgins, Tim Macker, Craig Meyer and Carlos Perez

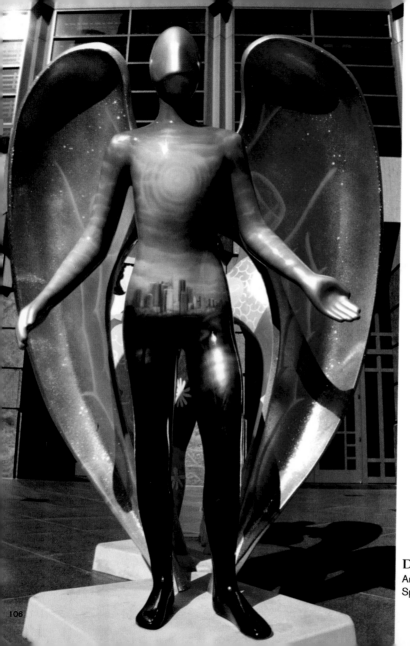

**Guardian Angel
of Women and Children** ▶
Artist: Pearl Beach
Sponsor: Good Shepherd Shelter
for Battered Women and Their Children

Day and Night Angel
Artist: Daniel Ponce Marquez
Sponsor: Hines Properties

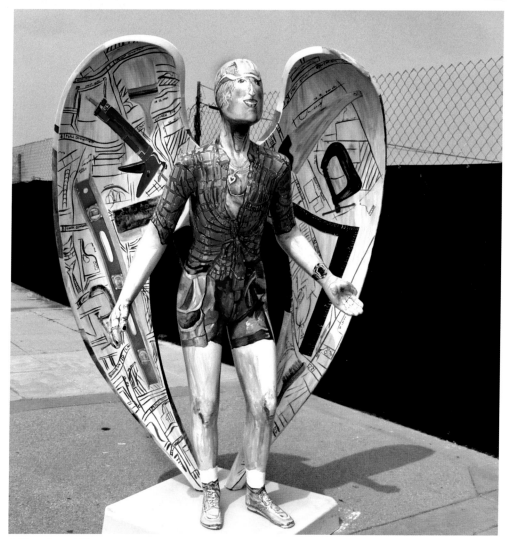

Alhambra Alive
Artist: Jodi Bonassi
Sponsor: Alhambra Central Business District Association

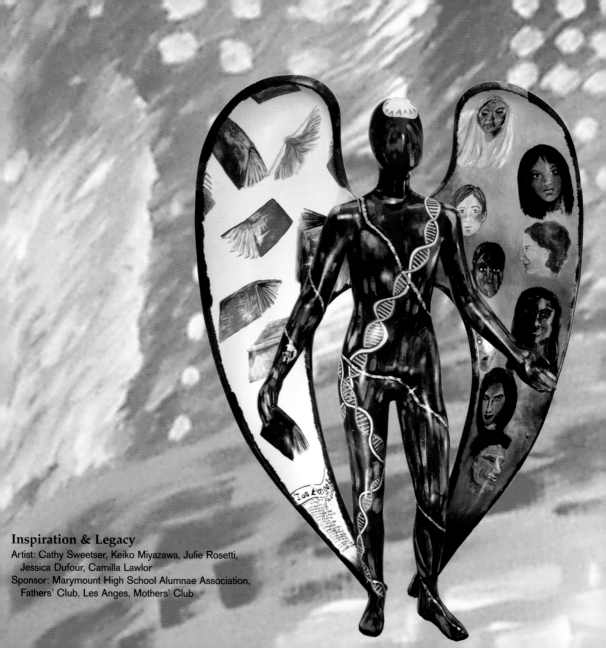

Inspiration & Legacy
Artist: Cathy Sweetser, Keiko Miyazawa, Julie Rosetti,
 Jessica Dufour, Camilla Lawlor
Sponsor: Marymount High School Alumnae Association,
 Fathers' Club, Les Anges, Mothers' Club

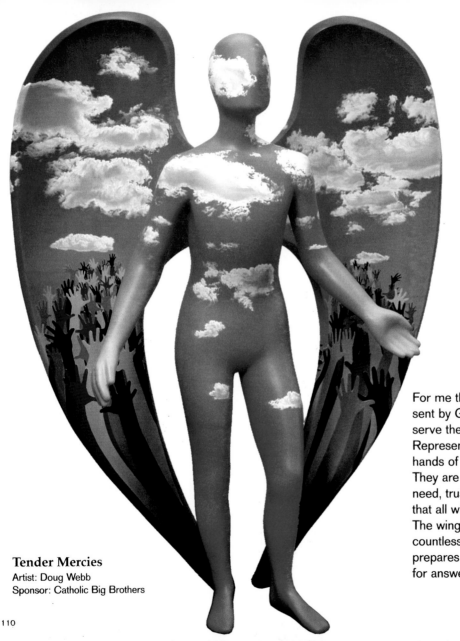

For me the angel is an emissary, sent by God, to protect and serve the needs of humankind. Represented here are the open hands of children of all colors. They are reaching upward in need, trusting, as children do, that all will be taken care of. The wings have collected the countless needs as the angel prepares to ascend to heaven for answered prayers.

— Doug Webb

Tender Mercies
Artist: Doug Webb
Sponsor: Catholic Big Brothers

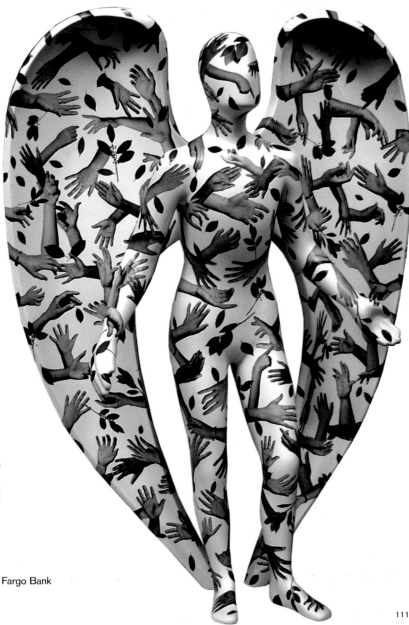

Hands of an Angel was inspired by the children and volunteers that are part of Camp Laurel, a non-profit camp program that serves children living with HIV and AIDS. The hands, from the children and the volunteer that help bring hope to their lives, are a source of inspiration, teaching us to live life to its fullest. The laurel leaves symbolize hope for a cure.

We wish Hands of an Angel will inspire others to reach out to those in need . . . to reach out and become an angel.

— Donna Fedenko
and Margot Andrew, Founder,
Camp Laurel

Hands of an Angel

Artist: Donna Fedenko
Sponsor: Camp Laurel, funded by Wells Fargo Bank

Los Angeles is a multicultural city made up of immigrants who came here in search of a better life. Angel of Dreams has wings supported by history and carried by fortunes (which cover the back of the wings). A collage of stamps from around the world creates the underside of the wings.

— Ellen Burr

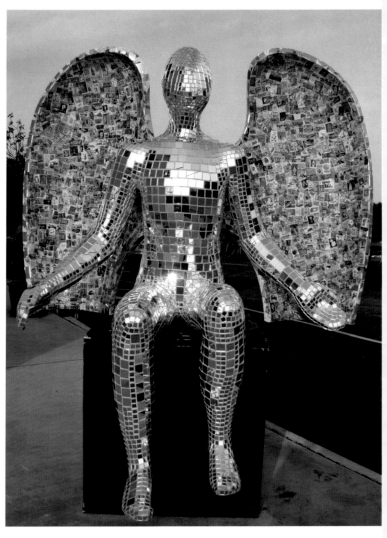

Angel of Dreams
Artist: Ellen Burr
Sponsor: Venice Theatre Works

Lumina: Angel of Our Reflection ▶
Artist: Dominique Moody
Sponsor: Carol and Dick Kemp

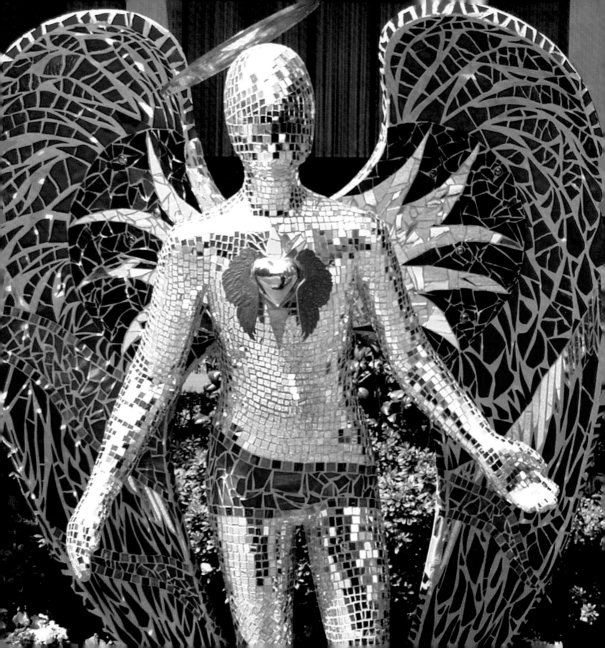

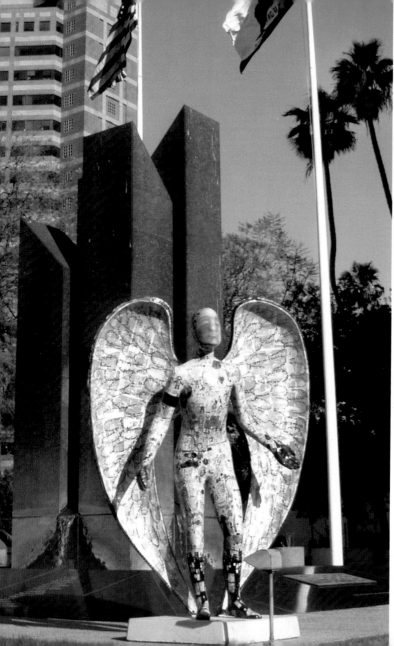

This angel is a representation of the many angels among us. These angels include officers protecting us currently—community members, teachers, parents and children. Written on the wings are the names of the 194 police officers killed in the line of duty since 1908. The body of the angel, covered with images from children's artwork, represents the youth of today and the future of tomorrow.

— Brandy Alexander

The Heaven Sent Hero
Artist: Brandy Alexander and Students
 of Weemes Elementary
Sponsor: LA Police Department's
 Grateful Employees Organization

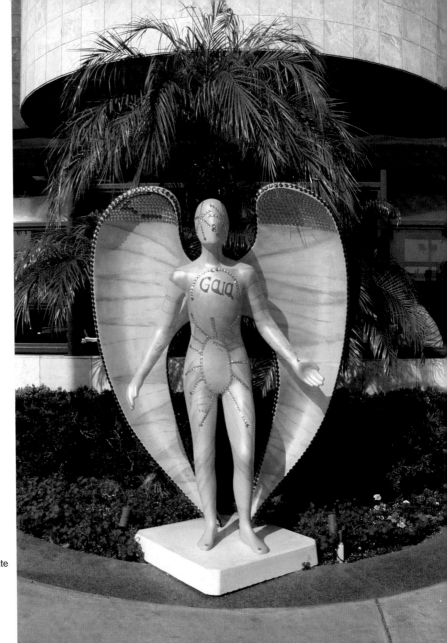

Gaia
Artist: Tsipi Perez
Sponsor: Mani Brothers Real Estate

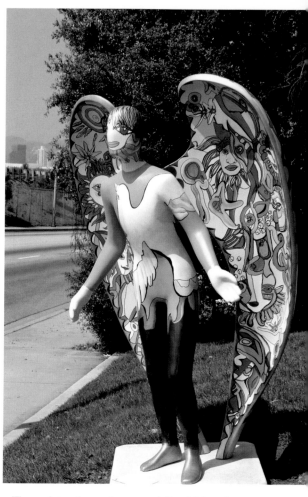

Angel of Peace
Artist: Beso Kazaishvili
Sponsor: Kelsey National Corporation

The safety of people, especially children is paramount to other things in life. I put on one side of the angel, a sun, and on the other, a moon. And between them, faces of children. I want them to be safe day and night. I want angels to watch over them.

– Beso Kazaishvili

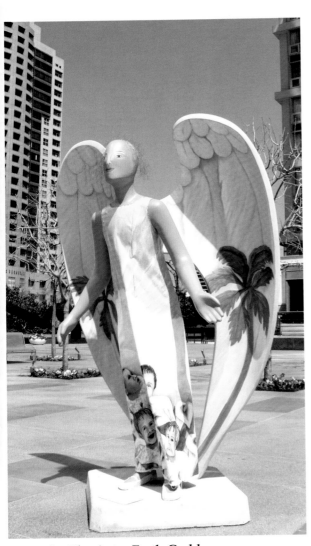

Tonatzin–The Aztec Earth Goddess
Artist: Dolores Guerrero-Torres
Sponsor: John Densmore and Leslie Neale

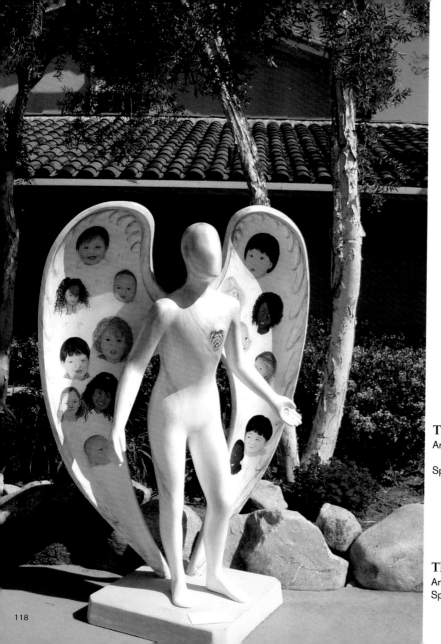

The Children's Angel ▶
Artist: Residents and Staff of Maryvale
 (Activities Department)
Sponsor: Maryvale

The Guardian
Artist: Karen Fredrickson
Sponsor: St. John Eudes Parish

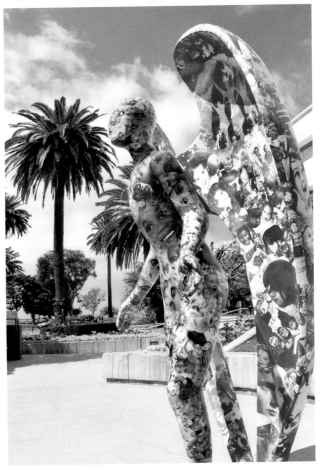

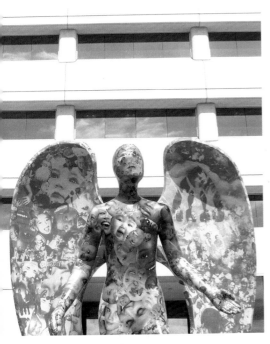

This angel was designed and decorated by the children and staff of the Activities Department of Maryvale. It represents all the children who have been cared for since the founding of Maryvale in 1856. We are the oldest care facility for young girls in LA.

– Mary Pat Cooper

COMMUNITY OF ANGELS

I wanted to contribute to the City of Los Angeles—my home for twenty-seven years. I have enjoyed living here and wanted to say thanks in this manner. It was simply a pleasure to contribute to a project that I knew would help so many children. To me every child is an angel.

— Ali Golkar

It is a rare opportunity when a vast city such as Los Angeles can unite as a community through a collaboration involving the arts. Since 1925, the mission of the LA Art Association has been to bring together the city through the language of the arts, so our participation in The Community of Angels Project allowed us to extend our vision.

— Ashley Emenegger, Executive Director, Gallery 825/LA Art Association

As we collaborated, fourteen of us interacting, all having different ideas, we learned firsthand about our interdependency and trust. It was a challenge at times. But we are grateful for having been given this opportunity to pool our collective creative resources to give something back to all of you.

— Neala Coan

I believe a spirit of caring for others and cooperation, respect and responsibility can grow. I would like to see neighbors, as well as neighborhoods, begin to work together. It could build self-esteem, a sense of belonging and build up a local economy as well as help our children learn important skills. It is always good to see people helping each other, volunteering and getting involved with making our cities more livable and our lives happier and more workable.

— Thomas Slagle

I was asked to assist in the design of the original angel "canvas" as I like to call it. My intent was to design a form that all artists could relate to and change their own creative ways.

— Tony Sheets

All the people I have met and dealt with while working on this project have been so wonderful and supportive. My sponsors have left me free to create within the theme of their angels. My prayers are that these angels speak to those who see them and inspire everyone to tap into their own creativity.

— Janine Anderson

If you read the newspaper every day, you can't help but realize how fortunate we are to live in a part of the world where we can take time to pursue our greatest interests. If there is to be famine, war, despair, apathy and shame, then let us give thanks that there is a time and place where we can rise above our limitations and celebrate the gifts of imagination and creation that we have been given. A city-wide art project, what a great fortune!

— Gus Harper

I hope that the Community of Angels will contribute to the unity of this city and, at the same time, celebrate its marvelous, shimmering, diverse mix of people, cultures and beliefs.

— Cindy Suriyani

I chose architecture as the theme for my angel. Both are protectors, the angels protect us from harm and the architecture protects us from the elements. Both provide shelter. I combined the facades of the city of my birth, Vilnius, Lithuania, with those of the city of my choice, Los Angeles.
— Saule Piktys-Zukerman

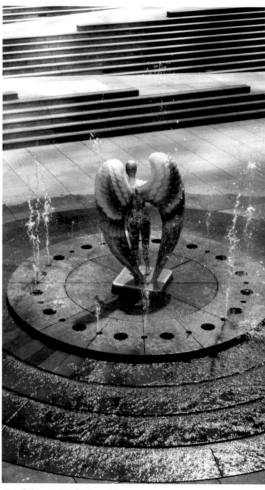

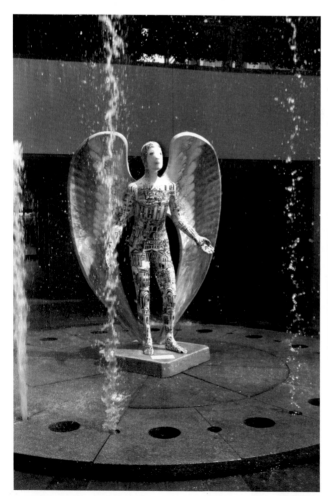

Architectural Angel
Artist: Saule Piktys-Zukerman
Sponsor: Equity Office

I was inspired by the Greek god Entheos who was said to have been the god of the common man. The idea was to include all people, all colors, and all religions as being potential angels: Rich or poor, man has the ability to become an angel. Everyone who approaches this angel sees themselves in this spirit. On the back of the wings rides all of mankind.

– Peter Liapes

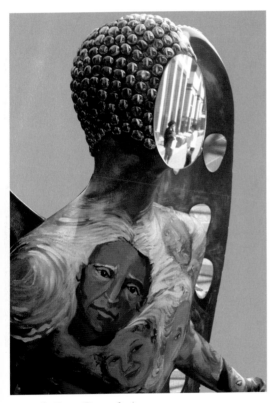

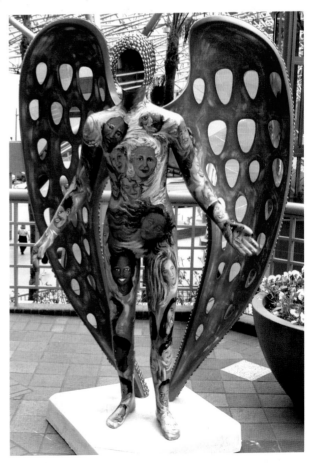

Angels In a Crowd
Artist: Peter Liapes and Carlotta Maggi
Sponsor: Trizec Hahn Office Properties

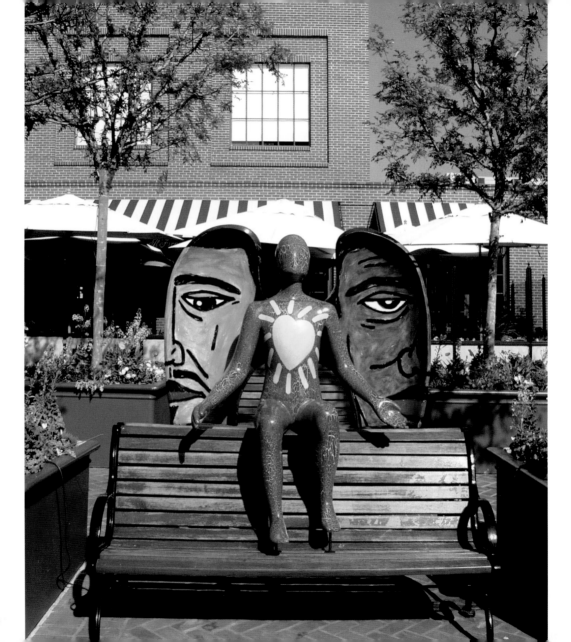

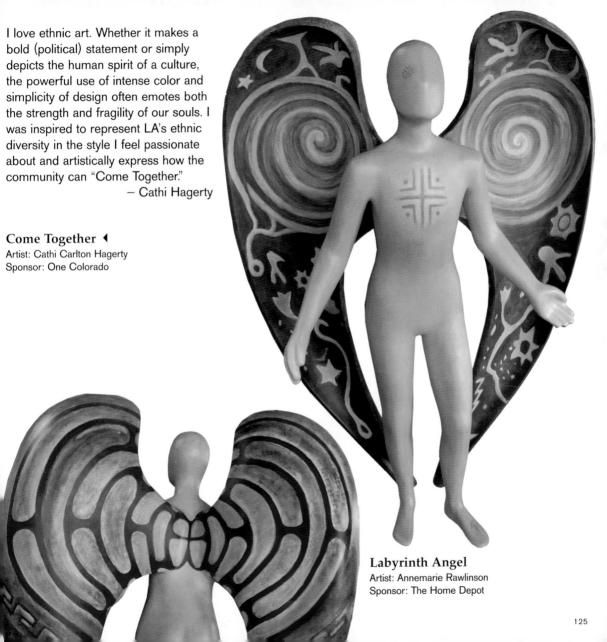

I love ethnic art. Whether it makes a bold (political) statement or simply depicts the human spirit of a culture, the powerful use of intense color and simplicity of design often emotes both the strength and fragility of our souls. I was inspired to represent LA's ethnic diversity in the style I feel passionate about and artistically express how the community can "Come Together."

— Cathi Hagerty

Come Together ◀
Artist: Cathi Carlton Hagerty
Sponsor: One Colorado

Labyrinth Angel
Artist: Annemarie Rawlinson
Sponsor: The Home Depot

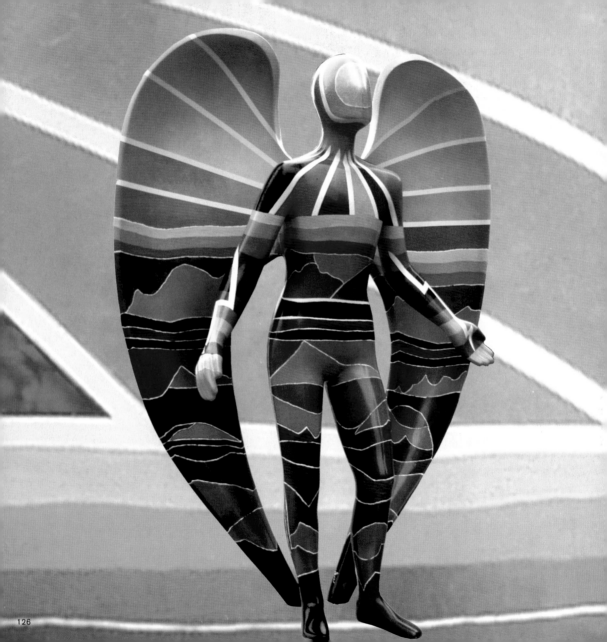

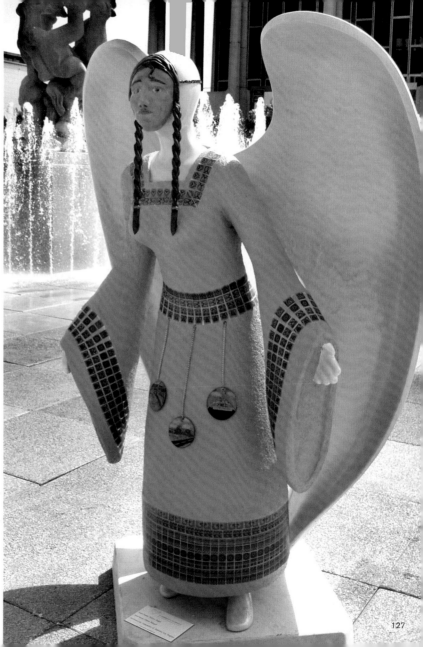

Native Angel represents the many people from different cultural backgrounds who were born here in Los Angeles, including myself, who now make up the native people here.
— Diana L. Watson

Native Angel
Artist: Diana L. Watson
Sponsor: Volunteers of America
Los Angeles

I wanted to make an image combining colors, shapes and forms inspired by a cosmic concept including heavenly skies and sunshine from above, as well as mountains and strata of earth from below, embuing the angel with spiritual qualities of mystery beyond our understanding.
— Arthur Secunda

Angel Light Angel Bright
SuperAngel of the Night ◀
Artist: Arthur Secunda
Sponsor: Walter Lantz Foundation

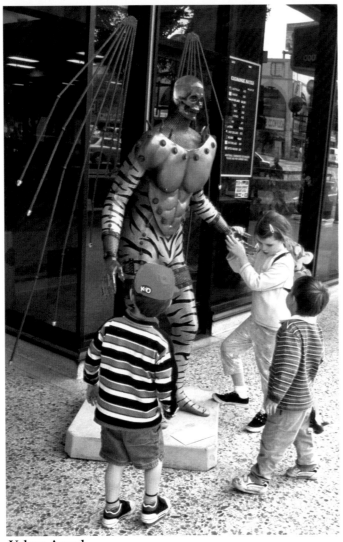

I approached the concept more sculpturally than painterly. I wanted my design to reflect the more urban side of Los Angeles. The rebar wings suggest freeways and a city under construction, the transparency of normally earnest hands indicates the transient nature of LA, and the tweaked animal patterns connote the city's unique style of passion.

– Philip Hitchcock

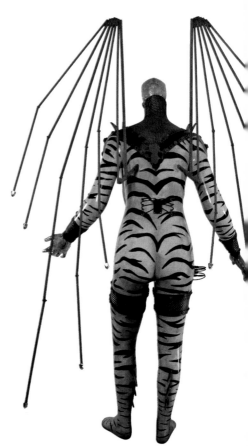

Urban Angel
Artist: Philip Hitchcock
Sponsor: The Cascio Foundation

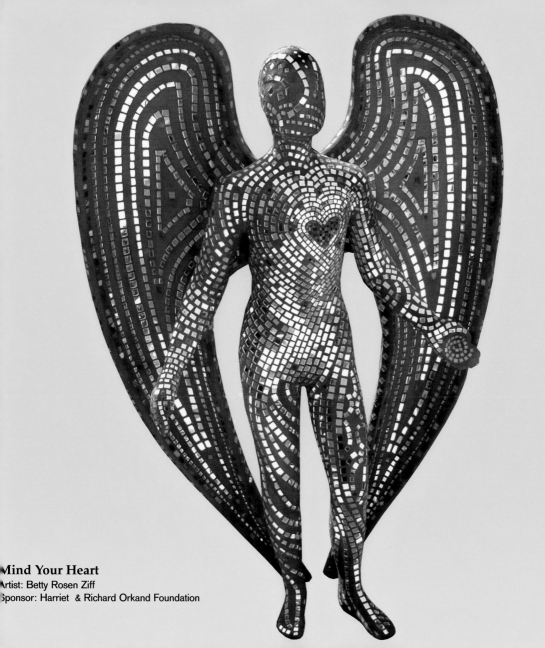

Mind Your Heart
Artist: Betty Rosen Ziff
Sponsor: Harriet & Richard Orkand Foundation

I have always been fascinated with quilts, powerful geometric abstraction created as art by American women. In designing the angel, the quilt became the structure for a commentary about our present view of the 1950s.

— Gwen Freeman

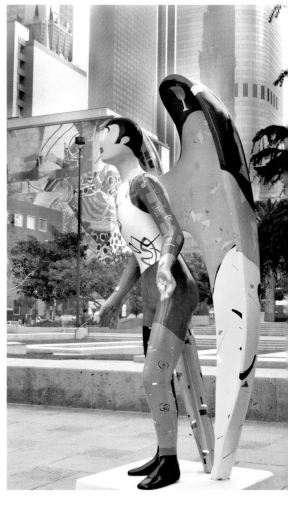

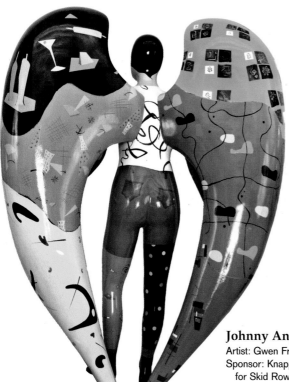

Johnny Angel
Artist: Gwen Freeman
Sponsor: Knapp, Petersen & Clarke
 for Skid Row Development Corporation

I wanted to use shape and color to bring the angel to life with as much power, exhuberance, playfulness, and momentum as possible.

— Jonye Feldman

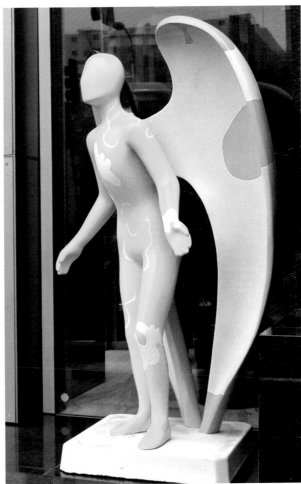

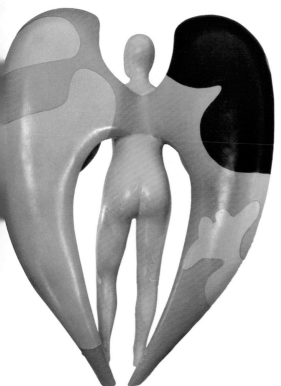

Fat Charlie
Artist: Jonye Feldman
Sponsor: Southern California Gas Company

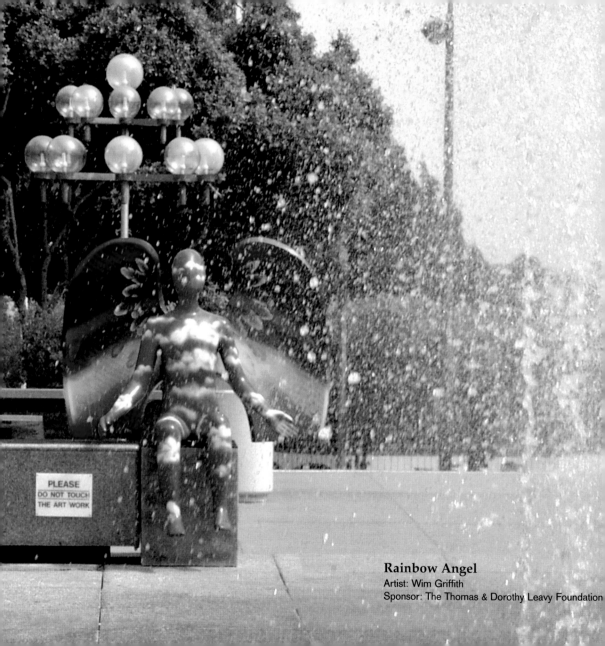

Rainbow Angel
Artist: Wim Griffith
Sponsor: The Thomas & Dorothy Leavy Foundation

PLEASE
DO NOT TOUCH
THE ART WORK

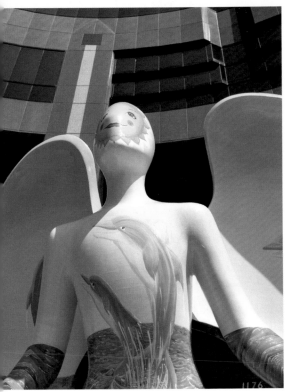

I wanted my angel to express joy, freedom, beauty, and a celebration of this life we have been blessed with. I remembered a whale-watching trip, when a school of dolphins swam playfully alongside our boat. Their carefree spirit, combined with the incredible beauty and depth of the sea and sky, was a wonderful experience and was the feeling that I wanted to display on my angel.

— Suzanne Rifkin

Celebration of Life
Artist: Suzanne Rifkin
Sponsor: Dynamic Home Care/Dynamic Nursing Inc.

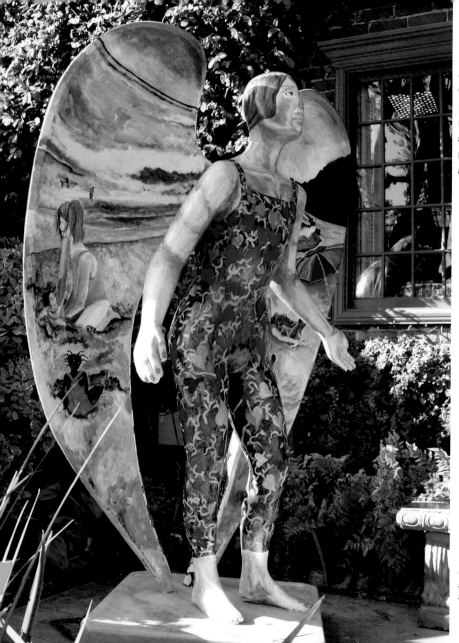

For the front I depicted a beach scene of my son, Spencer, and his friend, Gabby. For the back, I painted the children of our neighborhood. They are all special to me. The angel represents love, health, and spiritual abundance.

– Jodi Bonass

Angel Heart
Artist: Jodi Bonassi
Sponsor: Vons Foundation

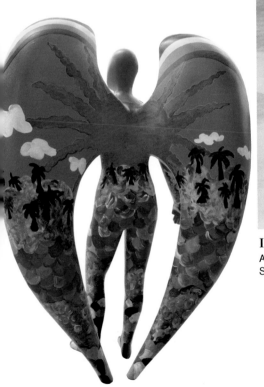

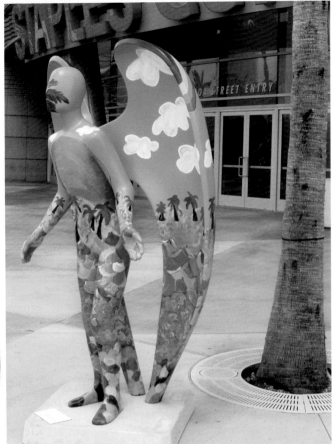

Inner-City Angel
Artist: Gina Stepaniuk and 3rd Grade Class from Sierra Park School
Sponsor: Staples Center for Inner-City Arts

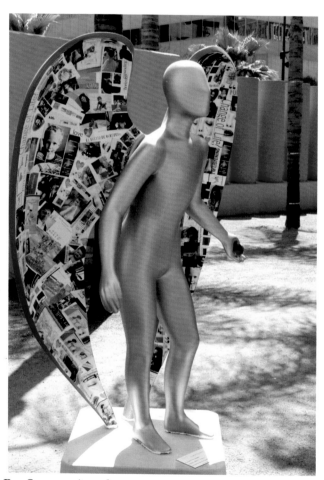

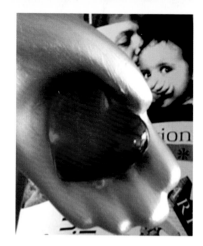

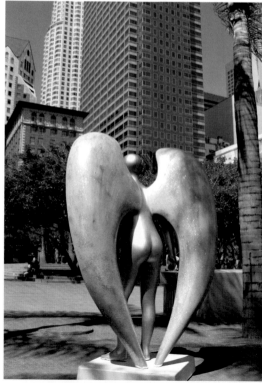

Per Sempre Angelo
Artist: Rosa Alvarez-Castellano
Sponsor: Harris Foundation

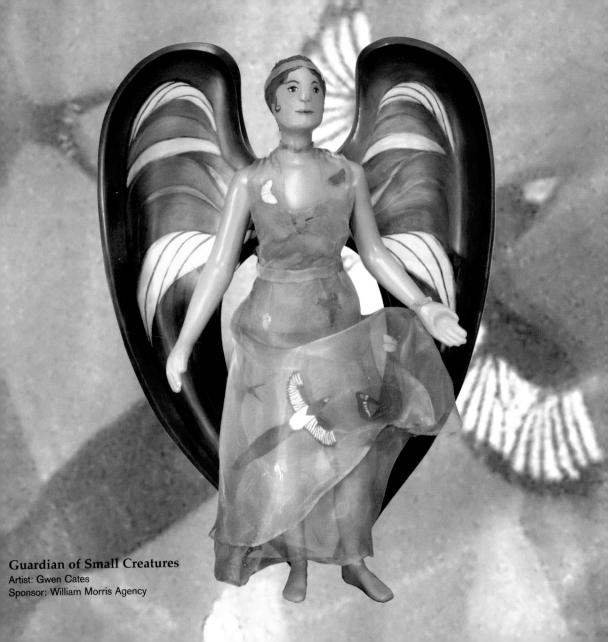

Guardian of Small Creatures
Artist: Gwen Cates
Sponsor: William Morris Agency

My work deals with the Holocaust. And while the Angel of Death (*Mallach Ha-Mavais*) came for so many, others were magically protected as if by messengers of God. My work is about the reconciliation of opposites—good/evil, dark/light—and about transformation.

— Nancy Kay Turner

Hand-In-Hand ▶
Artist: Pacific Hills Students with Paul Morsink
Sponsor: Pacific Hills School

Aleph: The Beginning and the End
Artist: Nancy Kay Turner
Sponsor: Loyola High School

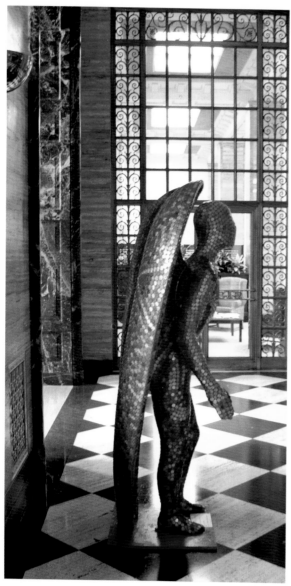

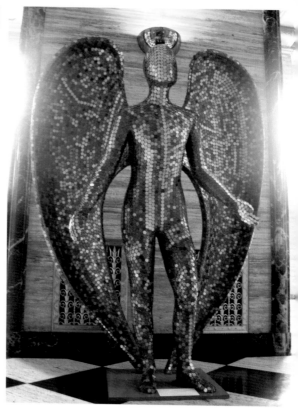

Spinneret ▶
Artist: Dori Atlantis
Sponsor: Southwestern University
 School of Law

Pennies From Heaven
Artist: Scott Berg
Sponsor: Mellon 1st Business Bank

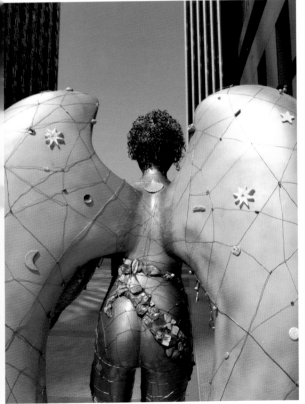

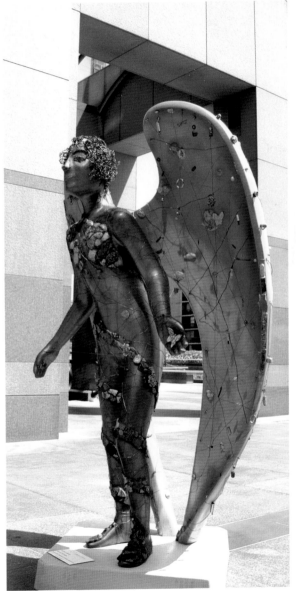

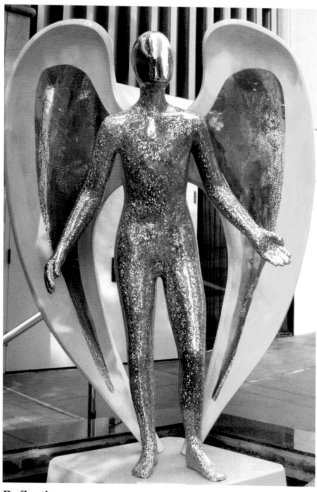

Under the holographs and paint on the wings are the ink handprints of friends and fellow artists. I wanted the soul of the community to carry the spirit of the community. It's about looking into the angel's face and seeing yourself.

— Anna Siqueiros

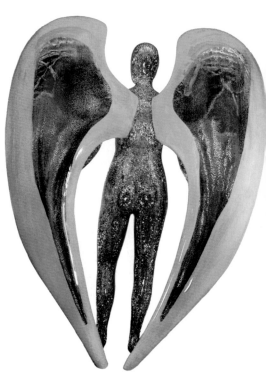

Reflections

Artist: Anna Siqueiros
Sponsor: Wilshire Grand Hotel

Our inspiration was the diversity of Los Angeles and a quote with which we had worked back in 1988, in our year-long master calligraphy class that brought the fourteen of us together. The quote from Hebrews: "Be not forgetful to entertain strangers, for thereby some have entertained angels unawares." The repeated words on her are "Angel" in at least forty-eight different languages indigenous to the Los Angeles area, as well as in Braille and sign-language.

– Neala Coan

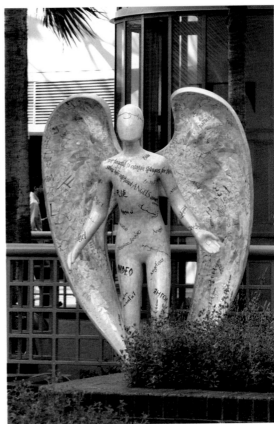

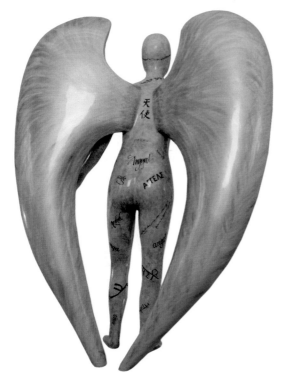

An Angel by Any Other Name
Artist: Neala Coan and The Studio Group of Calligraphic Arts
Sponsor: JDate.com

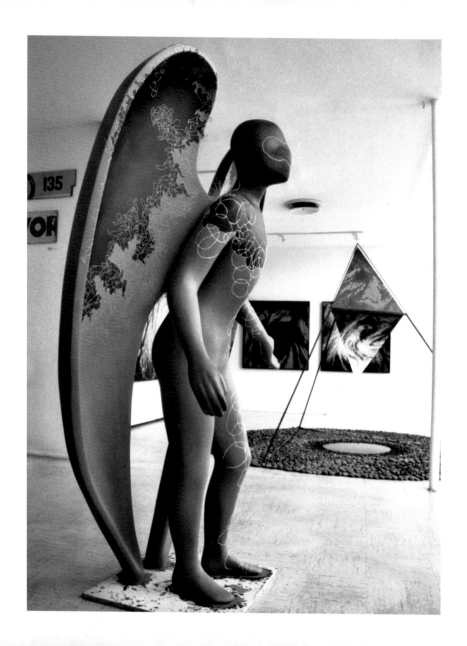

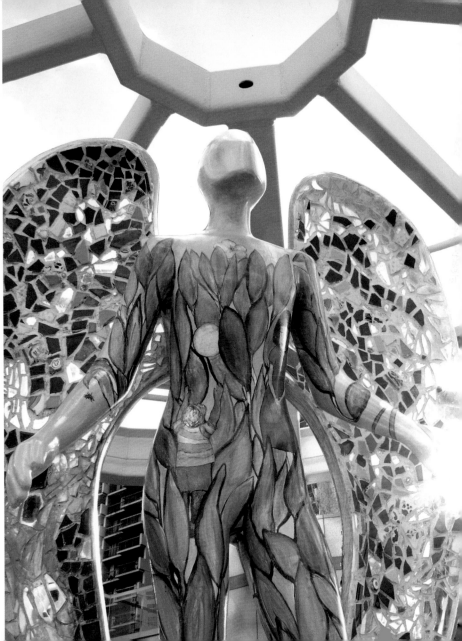

began thinking about the
angel in a universal sense,
the angel as a microcosm
of the world. Thus, the sky
for the upper torso, the
trees and living things
reaching to it, and the
earth below.

— Cindy Suriyani

The Garden
Artist: Cindy Suriyani
Sponsor: Non-Profit
Arts Corporation

Angelic Intersections ◄
Artist: Sharon Ben-Tal
Sponsor: Gallery 825/
LA Art Association

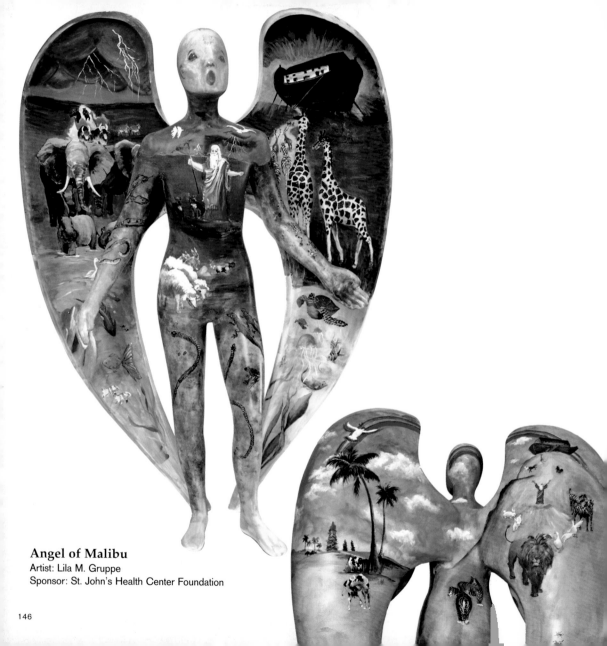

Angel of Malibu
Artist: Lila M. Gruppe
Sponsor: St. John's Health Center Foundation

146

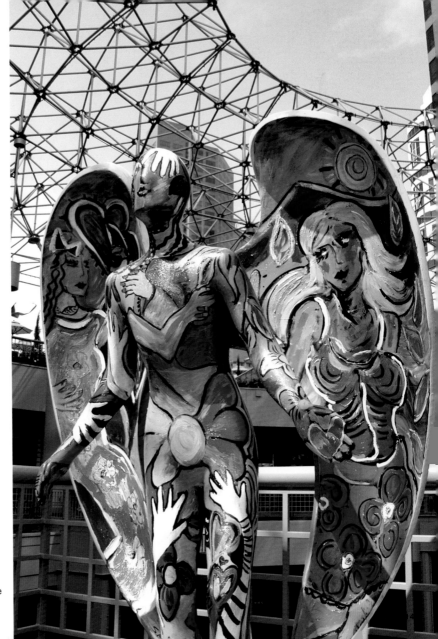

Angelica de Espero
Artist: Susan Manders
Sponsor: Anti-Defamation League

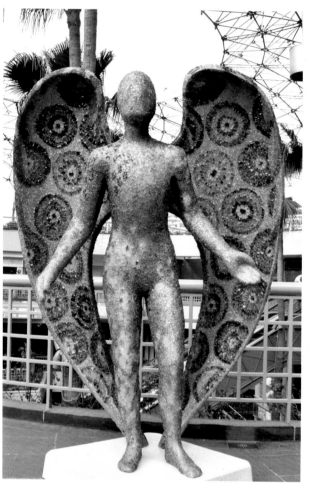

Gladys Glass
Artist: Annmarie Socash
Sponsor: Kevin and Britta Shannon

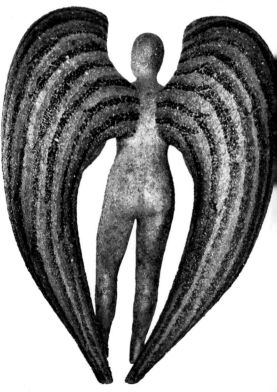

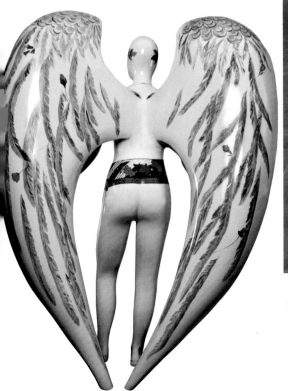

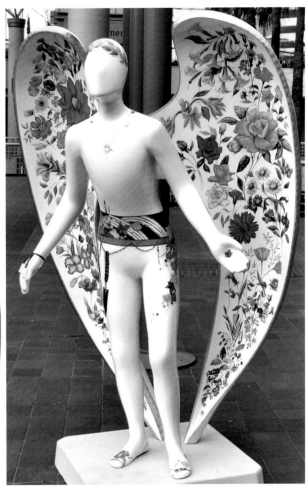

A Gardening Angel
Artist: Cindy Takahashi
Sponsor: Tosh and Amy Shinden

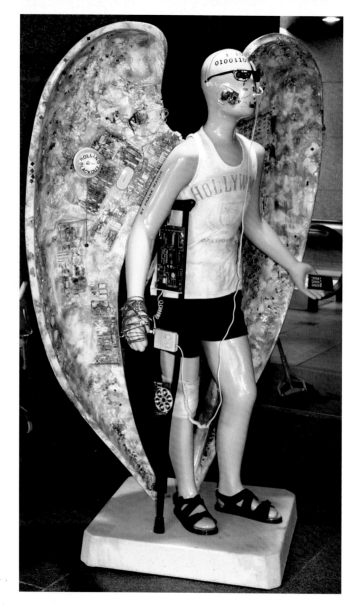

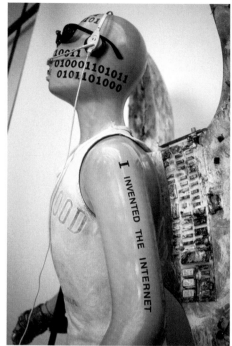

Technology has, as one of its facets, a dehumanizing quality—there is always a struggle between efficiency and humanity. My angel represents the attempts to to embrace technology while still maintaining a soul, i.e. "surviving" it. Technology has the power to save and destroy us, and must be embraced with caution, and yes, a touch of whimsy.

— Frank Mayor

Hi-Tech Survivor
Artist: Frank Mayor
Sponsor: Non-Profit Arts Corporation

Be An Angel
Artist: Dana Torrey
Sponsor: Volunteer Bureau
of Los Angeles

Los Angeles has always lived up to its name, City of Angels. Angelenos are philanthropic. They volunteer and care for one another. Los Angeles is filled with great cultural institutions, communities of faith and schools, colleges and universities. Our beautiful mountains, seashore and climate make our city an earthly paradise.

It is fitting that Los Angeles is the home of A Community of Angels. The artistic angels displayed all over town have increased pride in our community, while creating beauty and a sense of fun.

I am proud to have been Mayor of the capital city of the 21st century. The pages of this book remind us all of the diversity and beauty of Los Angeles, City of Angels.

— Richard J. Riordan
Mayor, City of Los Angeles
1993 to 2001

ACKNOWLEDGMENTS

Ken Martinet and Cal Winslow

**On the Brink
of Heaven and Earth**
Artist: Jacqueline Klein

It was late in 1999 when we first discussed the concept of a public art project that could benefit the youth programs of our organizations. It was to be the "angelic" interpretation of similar projects in other cities. We knew we had a shot at creating not only something wonderful for our kids, but also something wonderful for the community. What neither of us could foresee were the number of people, the real-life angels, it would take to make the dream a reality and a success. To all of you who have made it a success, we are forever grateful. To a certain few, we must extend our special recognition:

From the outset, we envisioned the life-sized angels that would become the canvas for the artists of LA and the whimsy of school children. We thank Tony Sheets for understanding that vision and creating the original angel sculpture.

Without the support of each and every member of the Board of Directors of both the Volunteers of America and the Catholic Big Brothers, this project would never have taken flight. We extend our special thanks to Lou Fogelman, for giving hundreds of volunteer hours guiding the communications and merchandising of A Community of Angels and to Tom Duchene for giving our printed material such quality and flair.

The Los Angeles Convention & Visitors Bureau and the Volunteer Bureau of the Office of the Mayor championed our efforts. Our special thanks to Robert Barrett and Karen Wagener—these "guardians" extended their credibility to the project and sometimes unilaterally removed barriers to getting these beautiful angels on the streets. We might not have had so many angel masterpieces among us without the daily inspiration, enthusiasm and support of Shep Ross and the incredible and unflappable logistical talents of Ruby Godinez. They made the angels fly all over the city.

And thank you to our "messengers." Thank you Alexandra Nechita for being such an inspiring, dynamic and enthusiastic spokesperson for the project. Thank you Pat Thompson and Fraser Communications for orchestrating the creation of a Web site that has attracted millions to our angels and cause. Thank you Marnie Tenden, Michele Dugan and Hannah Kaufman for your wonderful photographs, this book, and all the other creative efforts you have undertaken to make this project come alive. Thank you John Stoddard and the Wilshire Grand for giving us space for a studio and store to make it real for the people of LA.

Most importantly, we extend our gratitude to our sponsors and artists. Without your generous support, artistic talent, and inspiration, our goal of "giving kids a chance to soar" would never have taken flight. You are truly a community of angels.

Finally, we want to acknowledge our families for being there to understand, inspire and support us. I, Cal, thank Karyl and Sheree for believing in my idea. Shelli, you helped make that dream come true. I, Ken, thank my supportive wife, Peggy, and my daughter, Catharine. We couldn't have done it without you.

Because so many of you understood the mission, gave of your time to make it happen, and never gave up, feel good in knowing that you have made a very big difference in your community. You are all angels.

Cal Winslow – Volunteers of America
Ken Martinet – Catholic Big Brothers

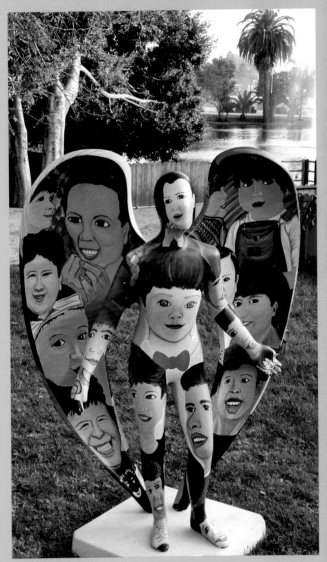

Children of LA
Artist: Rodolfo Cardona
Sponsor: Farmers Insurance

INDEX OF ARTISTS

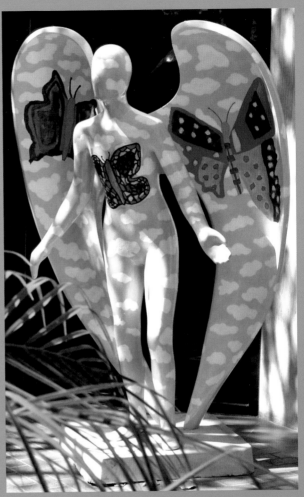

Day Dreams
Artist: Susan Reichman and the children from Kid's Choice 2001
—Will Rogers Elementary School
Butterflies painted by: A.C., J.E., A.M., B.P., S.H., B.C.
Sponsor: Ocean Park Community Center

INDEX OF SPONSORS

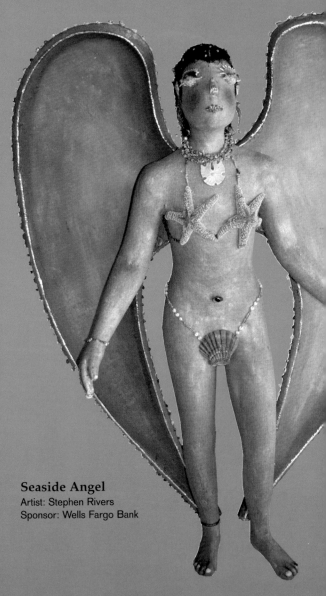

Seaside Angel
Artist: Stephen Rivers
Sponsor: Wells Fargo Bank

157

ANGELS WITHOUT WINGS

The following Angels were not completed in time to make the publication date for this book. They may be viewed on A Community of Angels Webs site at **www.acommunityofangels.com**

Labyrinth of the Heart Angel
Artist: Jane Boyd

Postcard from LA
Artist: Ada Pullini Brown
Sponsor: CommonWealth Partners LLC

Angel to the Seasons . . . The Colorist Angel
Artist: Myra Burg

Solar Angel
Artist: The Children of Hillsides
Sponsor: Zelman Development

Illuminating Realities
Artist: Alessandra DeClario

Beach Angel
Artist: Sabine Dehnel
Sponsor: Rotary International District 5280

Angel Eyes
Artist: Vernon Finney
Sponsor: Bob and Patricia Sievers

A Showering of Love
Artist: Karen Fredrickson
Sponsor: Avery Dennison Corporation

The Angels of the Past and Present
Artist: Hector Gonzalez and Students of Los Angeles
 Alternative Education

The Angel of Amazing Grace
Artist: Genice Grace

Tribute to Sharon Prewitt Katell
Artist: Jake Hooper
Sponsor: Katell Properties and LA's BEST After
 School Enrichment Program

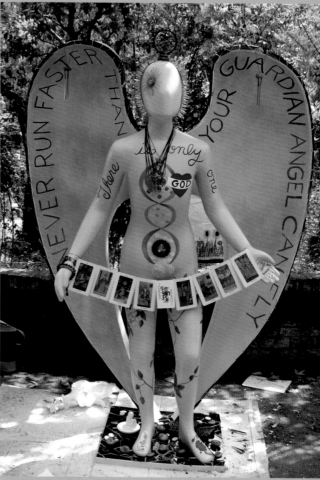

Allegra's Allegory is an attempt to represent many of the various religions that celebrate a faith in a higher being.
— Barbara Lazaroff

Allegra's Allegory (work in progress)
Artist: Barbara Lazaroff
Sponsor: Jackson National Life Distributors, Inc.

The Making of an Angel
Artist: Nomi Isak
Sponsor: John C. Cushman, III and Lynn A. Williams
 of Cushman Realty Corporation

TBD
Artist: Susan Kornfeld

Angelic Hands
Artist: Tracy Lundy
Sponsor: St. Mel Parish Community

Little Angels
Artist: Fred Mugford
Sponsor: Arden Realty

Alegria
Artist: Tsipi Perez
Sponsor: Mani Brothers Real Estate

Palms at Dusk Angel
Artist: Theresa Powers
Sponsor: Paul, Hastings, Janofsky & Walker LLP

"faith!" The Marble Angel
Artist: Gary Romanowski
Sponsor: Angels Attic, Donated by Kelsey Family Foundation

Our Gardening Angel
Artist: St. Bernardine of Siena Students
Sponsor: St. Bernardine of Siena Catholic Church

Tribute to René Magritte
Artist: Jerzy Skolimowski
Sponsor: Lowe Enterprises, Inc.

Michael
Artist: Annmarie Socash
Sponsor: Griffin Industries

Arf Angel
Artist: Joan Tenowich
Sponsor: BP

Blue Note
Artist: Billy Dee Williams

Gregory
Artist: Hiro Yamagata
Sponsor: Ring Financial

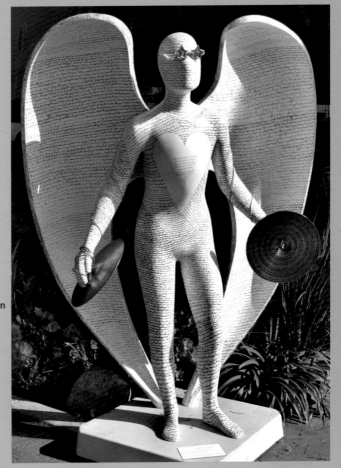

When you see my Angel you only see the outer surface of the project,
but if you accept its "invitation" and visit whatoneangelsees.com . . .
you're led on a journey of interactive discovery!
– Walter Lutz
What One Angel Sees
Artist: Walter Lutz
Sponsor: California Philharmonic Orchestra

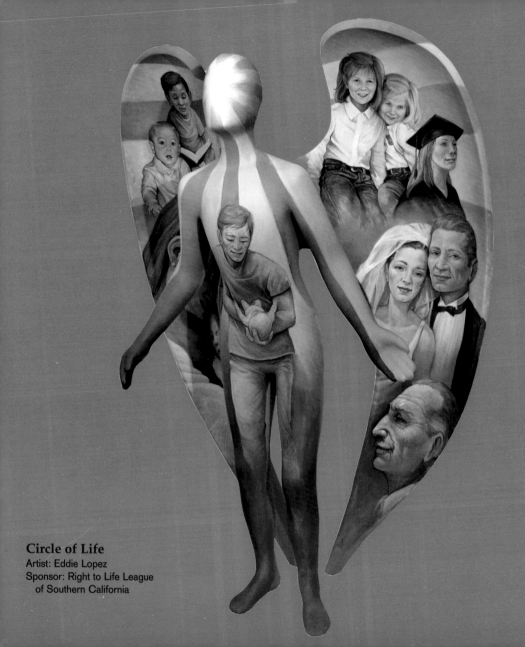

Circle of Life
Artist: Eddie Lopez
Sponsor: Right to Life League
of Southern California